doodletopia
MANGA

CHRISTOPHER HART

doodletopia
MANGA

DRAW, DESIGN, and COLOR
Your Own SUPER-CUTE
Manga Characters and More

WATSON-GUPTILL PUBLICATIONS
Berkeley

Published in the United States by Watson-Guptill
Publications, an imprint of the Crown Publishing Group,
a division of Penguin Random House LLC, New York.
www.crownpublishing.com
www.watsonguptill.com

WATSON-GUPTILL and the WG and Horse designs are
registered trademarks of Penguin Random House LLC

Library of Congress Cataloging-in-Publication Data

Names: Hart, Christopher, 1957- author.
Title: Doodletopia : manga : draw, design, and color
 your own super-cute manga characters and more /
 Christopher Hart.
Description: Berkeley : Watson-Guptill, 2016. | Includes
 bibliographical references and index.
Identifiers: LCCN 2015047882
Subjects: LCSH: Comic books, strips, etc.—Japan—
 Technique. | Comic strip characters—Japan. |
 Cartooning—Technique. | Drawing—Technique. |
 Doodles. | BISAC: ART / Techniques / Drawing. | ART /
 Techniques / Cartooning. | ART / Popular Culture.
Classification: LCC NC1764.5.J3 H369195 2016 | DDC
 741.5/1—dc23
LC record available at http://lccn.loc.gov/2015047882

Trade Paperback ISBN: 978-1-60774-693-5

Printed in the United States of America

Design by Debbie Berne

Contributing Artists:
Akane
Ero-Pinku
Inma R.
Nao Yazawa

10 9 8 7 6 5 4

First Edition

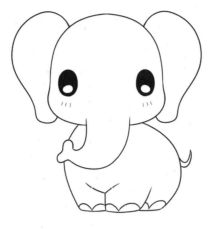

To my loyal readers—and new ones, too!

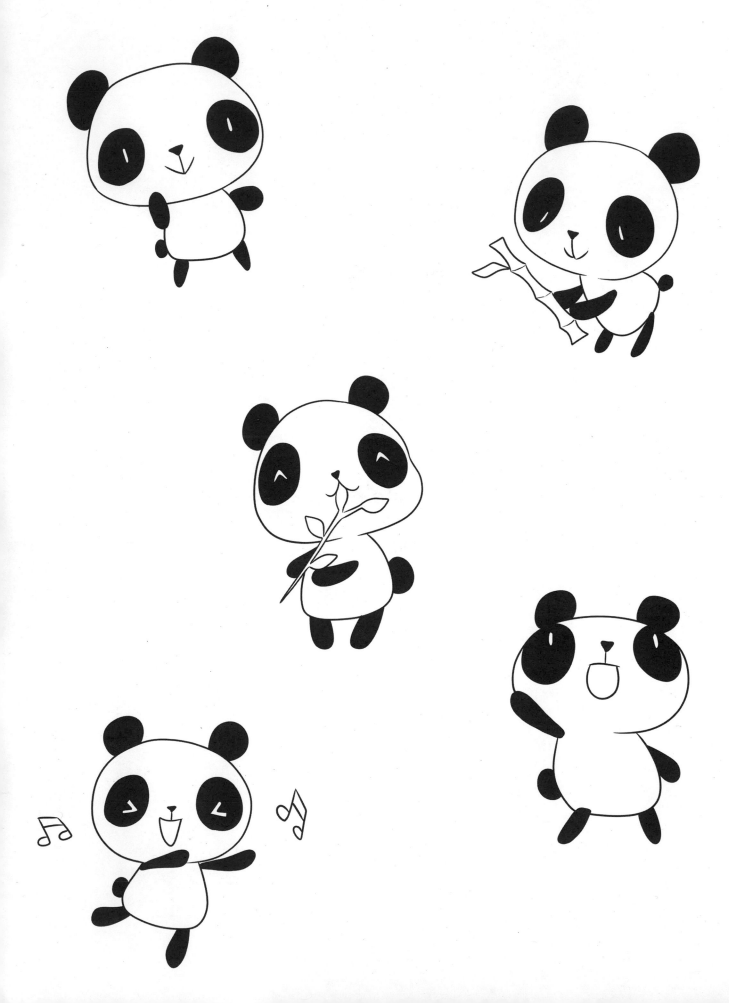

contents

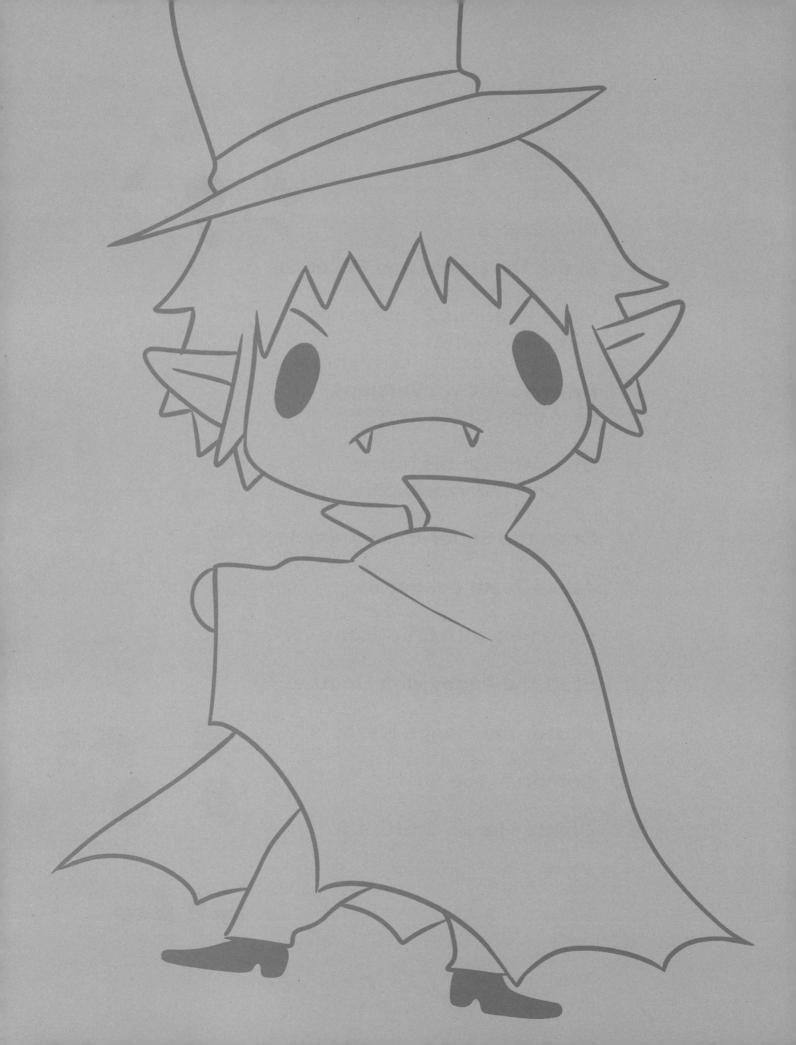

introduction

All through the ages, humans have doodled. In prehistoric times, they doodled on cave walls. As technology progressed, they began to doodle on stone tablets. Eventually, the art of doodling moved to the margins of loose-leaf paper, which was generally unappreciated by teachers trying to grade homework assignments. And there, the art of doodling languished—until now.

Recently, there has been a hue and cry for doodling. I'm not exactly sure what a "hue" is, but I recognize the sound when my readers cry. Therefore, I knew I had to do something—and fast. So I finished my cup of coffee, poured myself a second cup, finished reading the paper, and then sprang into action!

I discovered that *manga*, that amazingly popular style of Japanese comics, which features an irresistible array of characters, visual icons, and design motifs, could satisfy the demands of even the most dedicated doodler.

This book, the second in my series of interactive Doodletopia titles, brings you buckets of fun characters to draw, doodle, and color, plus cool projects, including many that you can use outside of this book, such as designs for your own personal stationery, bookmarks, emoticons, and more.

Doodletopia: Manga is your ticket to a world of creativity. Each chapter gives you a head start with visual prompts so that you can complete manga mascots, adorable animals, silly chibis, eye-catching designs, and more.

You may try to resist the pull of manga doodles. But if you are reading this introduction, it's already too late. The only thing that will help now is a pencil, and a tabletop to place this book on. Welcome aboard, fellow manga doodler!

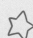

finish the heads and faces

Before you officially begin to draw your manga doodles, let's get those pencils up and running by reviewing a few fun character types. Keep your eyes focused on the basic shapes of the head, the eyes, and the hair. Notice how each drawing starts off with a rough sketch and becomes more refined with each successive step. There's no need to draw perfectly right from the start. Professional artists make mistakes. Even Michelangelo made mistakes. I believe the statue of David was initially supposed to be a manga action figure, but he couldn't get the spiky hair right. (I'm glad it worked out for him anyway.)

girl in a sun hat

Every artist needs to be able to draw the head from a variety of angles. The outline of the head appears to change shape as the head is turned to face different directions. That's why the front view looks so different from a profile, and so on.

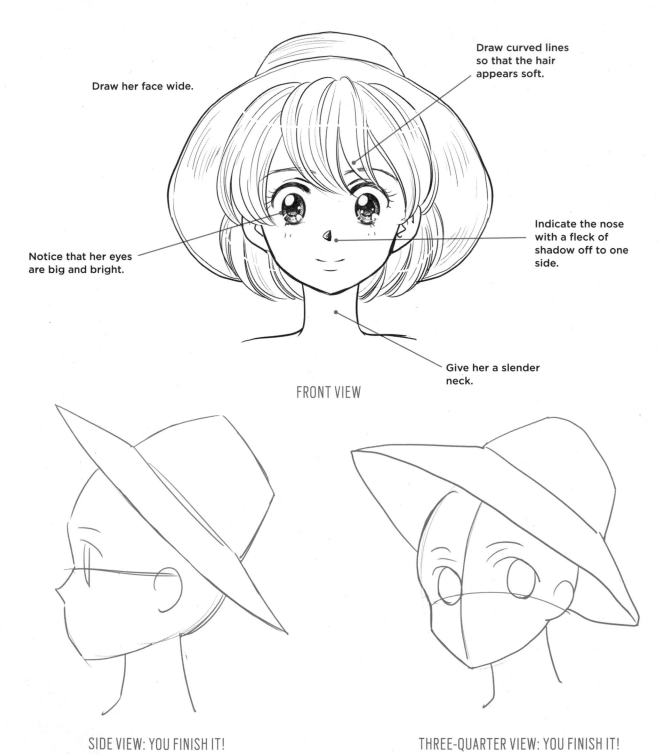

Draw her face wide.

Draw curved lines so that the hair appears soft.

Notice that her eyes are big and bright.

Indicate the nose with a fleck of shadow off to one side.

Give her a slender neck.

FRONT VIEW

SIDE VIEW: YOU FINISH IT!

THREE-QUARTER VIEW: YOU FINISH IT!

nice girl

The nice girl loves her parents, her siblings, her teachers, her employer, and all of her relatives. Of course, this type of person doesn't exist anywhere in reality.

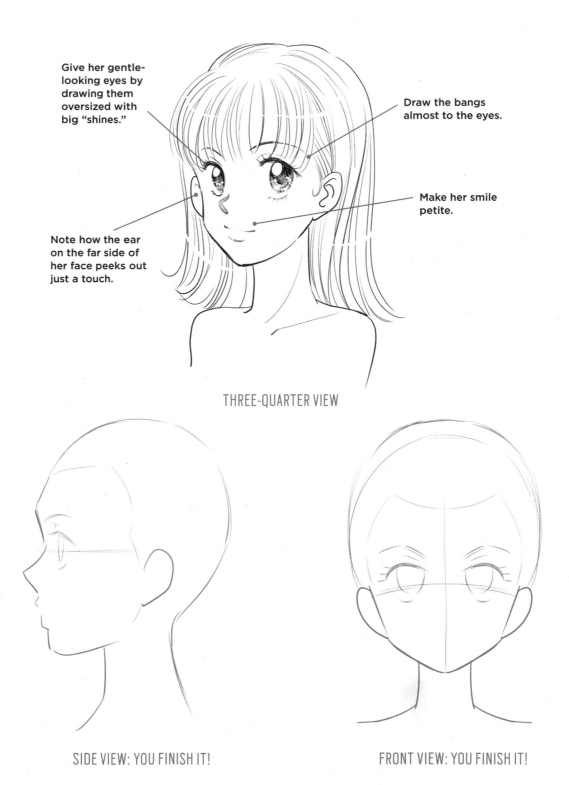

Give her gentle-looking eyes by drawing them oversized with big "shines."

Draw the bangs almost to the eyes.

Make her smile petite.

Note how the ear on the far side of her face peeks out just a touch.

THREE-QUARTER VIEW

SIDE VIEW: YOU FINISH IT!

FRONT VIEW: YOU FINISH IT!

goofy boy

This guy isn't hurting for self-esteem. In fact, he could use a little *less* of it. He thinks he's great, but he may be the only member of that fanclub. Let's look at how to draw this humorous character.

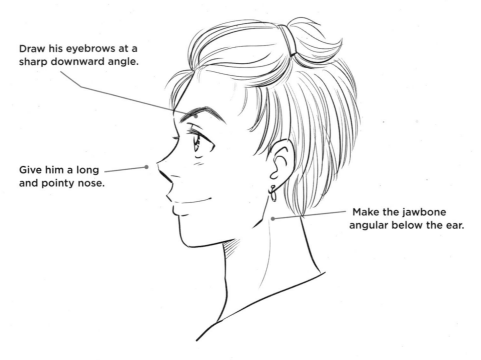

Draw his eyebrows at a sharp downward angle.

Give him a long and pointy nose.

Make the jawbone angular below the ear.

SIDE VIEW

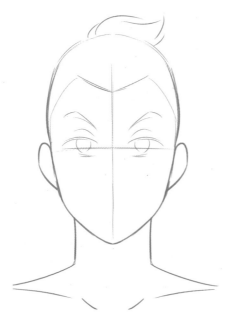

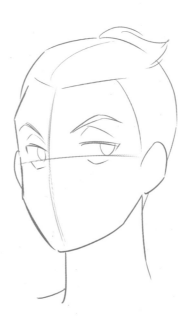

FRONT VIEW: YOU FINISH IT!

THREE-QUARTER VIEW: YOU FINISH IT!

funny girl with swirls

You don't have to be constrained by what you see in fashion magazines. Manga hairstyles run the gamut from simple to crazy and elaborate. This girl's hairstyle defies the law of gravity. Look at all the space between her head and her pigtails. It almost makes it look like the pigtails are levitating. (Maybe they're magic pigtails.)

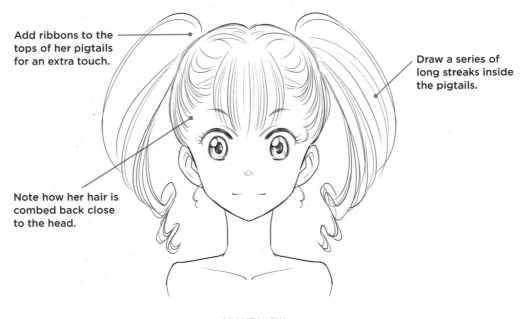

Add ribbons to the tops of her pigtails for an extra touch.

Draw a series of long streaks inside the pigtails.

Note how her hair is combed back close to the head.

FRONT VIEW

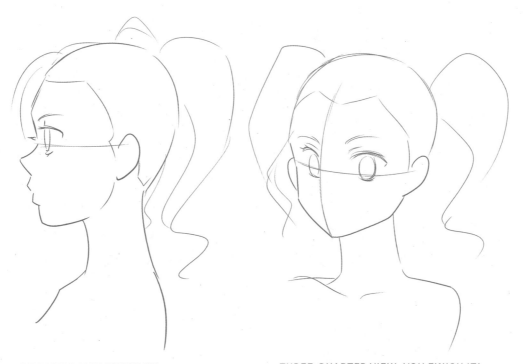

SIDE VIEW: YOU FINISH IT!

THREE-QUARTER VIEW: YOU FINISH IT!

make hilarious expressions with silly selfies

What's more fun than taking a selfie? Taking a selfie as a couple. Whether it's done with a cell phone or in a photo booth, taking pictures of yourself is fun, especially if you can get away with it during class.

In this chapter, you'll trace the drawings, and also fill in the details, in order to create a complete comic scene. If you want to take it to the next step, you can color both characters. For humorous scenes, keep the colors bright and bouncy. And here's another important tip: draw the expressions a bit uneven. That makes them look silly. (Sort of like the photo on your driver's license.)

him and her

You can give her a smile like his or an embarrassed expression. For an embarrassed look, draw blush lines—short, horizontal lines under each eye. You can also draw a speech balloon from either character or from both characters. I imagine he might say, "You're going to want to frame this picture." And she might respond, "Sure, right after I crop you out."

a purrrr-fect picture

Cat-girls are a fixture of manga, appearing in all genres. They've got cat ears and tails, and, less frequently, split upper lips, and really, really less frequently than that—litter boxes. There are even cat-boy characters. This cat-boy wears a hat. Draw the ears poking through his knit cap.

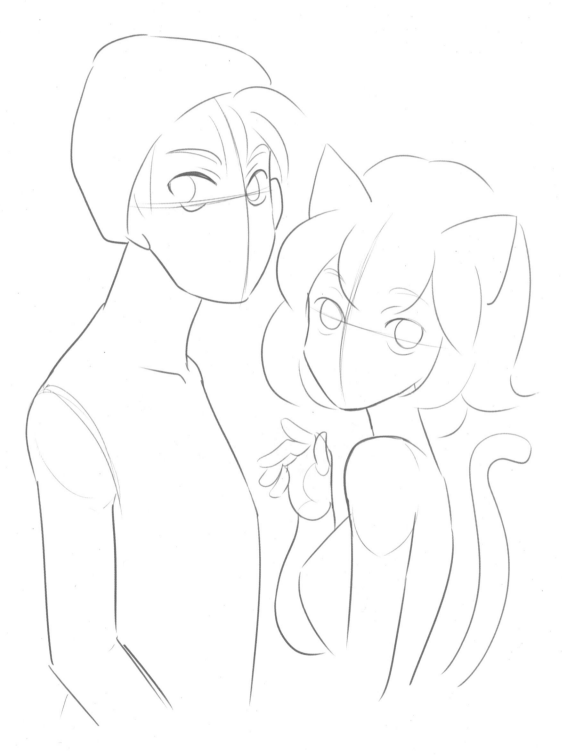

magical critters and galaxy girl

Magical playmates are cute, but they can get annoying. Anyone who has had one as a pet will tell you that they appear at the crack of dawn, while you're sleeping, and repeat the same four words over and over: "Can we play now? Can we play now? Can we play now?"

You can fill in the drawing as is, or add another magical creature that you create from scratch. How about a flying frog with a unicorn-style horn?

whose idea was this?

It's fun to give couples personalities that don't quite mix. Here, she's talked him into taking her to a foreign film about unrequited love in the Victorian era. Bet he can't wait to see that. What type of clothes do you envision him wearing? A cap of some sort? A sweater? A jacket with the collar up? A vest? Sunglasses? An eyepatch?

Consider adding a background to the picture. You can also draw someone sticking their head into the picture from the side and making a stupid face.

chibi greetings

You may have to draw a stack of books underneath these chibis to make them tall enough to reach the camera lens. Make sure to use your Christopher Hart drawing books! For the expressions, remember that chibis like to play it up for the camera. Want to add another element? How about giving one of them eyeglasses or ribbons in her hair?

are we great or what?

This couple can't pass up an opportunity to look at their reflections in a store window. You've got to wonder if he's aiming that thing at both of them, or only at himself. For argument's sake, let's pretend he's interested in capturing her picture, too.

If you want to do more for this picture, add a *thought balloon.* A thought balloon shows what a character is thinking. His might say, "I look fabulous!"

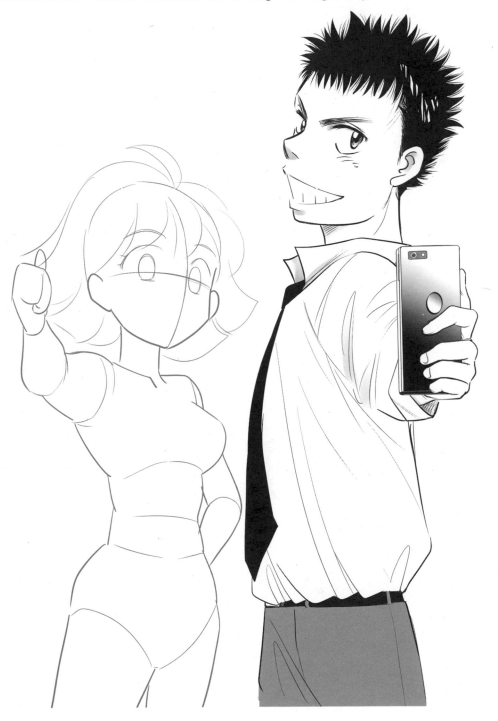

man's best friend

Here, you see a kid waving his hand behind a dog's head, making the dog look silly. (As if the dog is the only one that looks silly . . .) If you'd like to take this silly picture and put it into overdrive, then draw the dog looking at the guy and saying, "Weird."

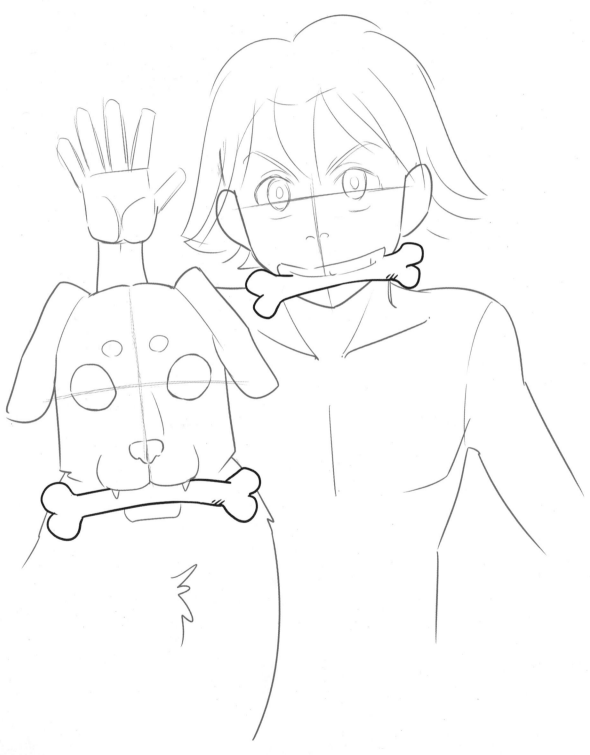

don't take the picture yet!

Click! Too late. The shot's been taken. But why doesn't she want her picture taken? That's where you come in. Draw a sticky stream of goo dripping from his funnel cake. He can say goodbye to any hope of a second date!

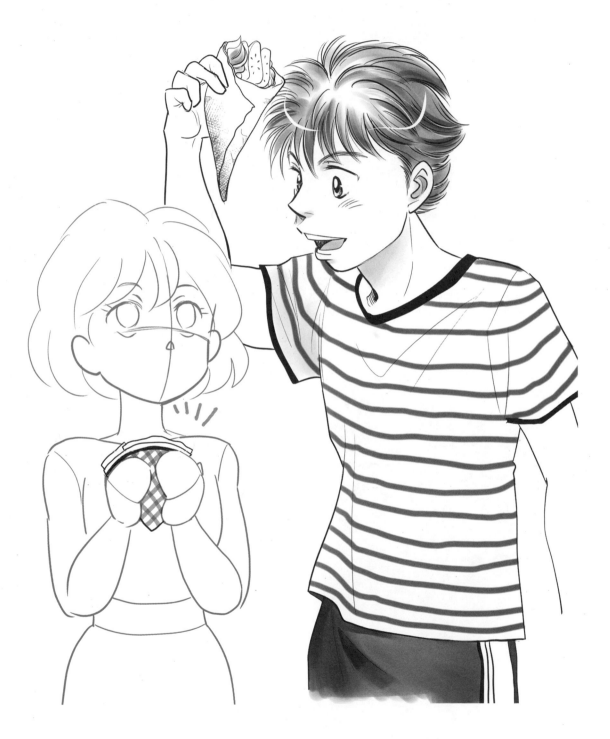

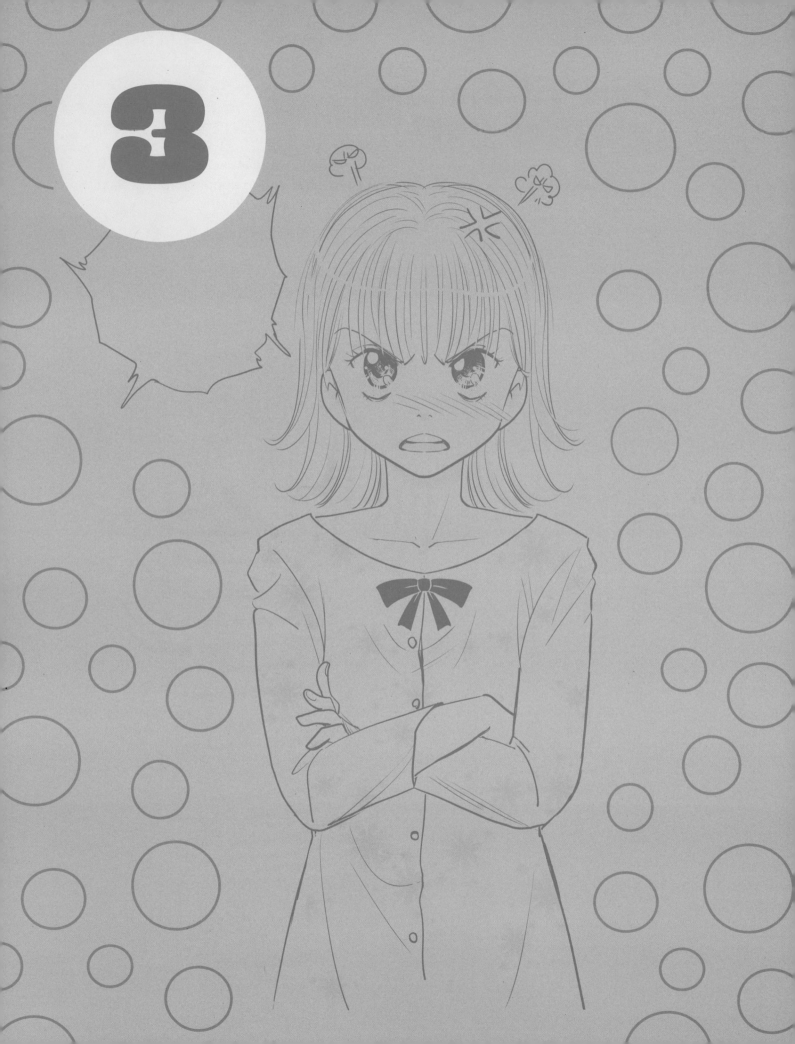

draw your own versions of manga characters

Now let's take things to the next level: freehand drawing. Follow the step-by-step instructions and then draw your versions of the manga characters on the opposite page. What if yours comes out looking somewhat different from the character in the instructions? That will also work! For example, if you drew the character with a longer haircut, that makes a fashion statement. You can also go further and change the expressions, too. It's your turn to draw whatever you want!

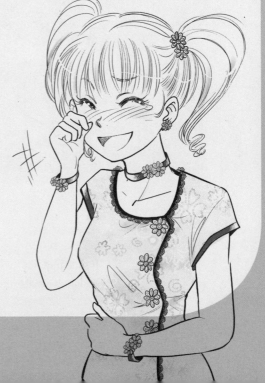

happy girl

Characters who are happy tend to put everyone around them in a good mood. This girl glances at the viewer wiht an appealing smile.

On the opposite page, you can draw this character as she appears, or create your own version. For example, you could give her closed eyes, which would turn her expression into a laugh. You could also remove her hat or give her pigtails.

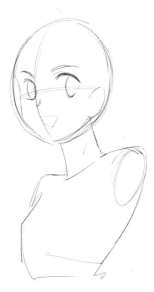

Keep the shapes very basic.

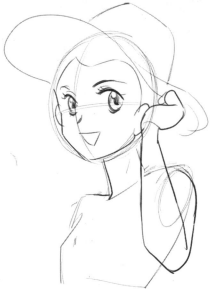

Once the shape of her head is in place, then you can draw the hat.

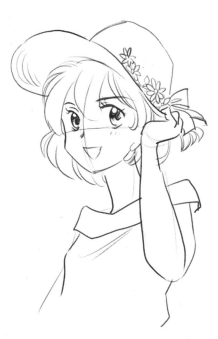

Notice that her upper eyelids are quite long.

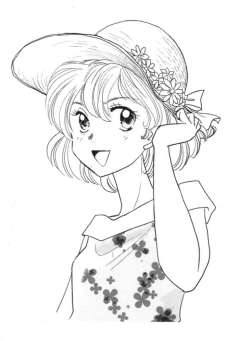

Draw the hair relaxed, but not messy, for a casual look.

draw your own cheerful character!

mr. wonderful

Everyone loves to have a character to hate. And he's it! He could pass for a leading man, if only his haircut weren't so horrible, his clothes weren't creepy, and he weren't so annoying. You can make this comedic character even goofier by drawing him with a wide, toothy smile.

Start with the basic head and the eyes.

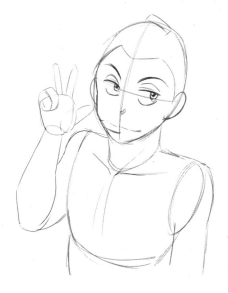

Draw the hairline.

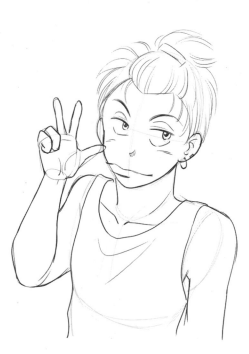

Draw horizontal eyelids to give him a dopey expression.

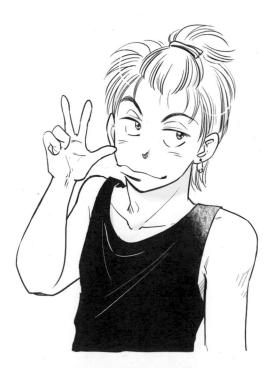

Draw a wide mouth for a funny look.

draw your own oddball character!

...

"i'm sooooo mad!"

Anytime smoke spurts from a person's head, they're probably upset. If you don't pick up on that, there are other clues as well. Eyes that look like they could kill are yet another hint.

Draw your own version of this angry girl and fill the empty speech balloon with some type of a caustic comment. Who's she talking to? Her boyfriend? Or perhaps, I should say, her *soon-to-be-former* boyfriend?

Draw the character facing directly forward in a front view.

For the face: draw her eyebrows together at a downward angle. For the body: draw her shoulders squared off, giving her a tense look.

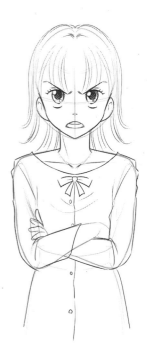

Give her a pretty outfit.

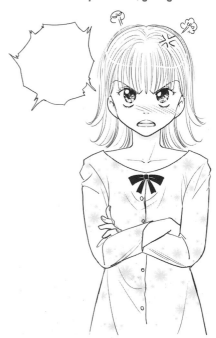

Add a few special effects, like the puffs of steam.

draw your own furious character!

...

"ha ha! that was a good one!"

Blush marks are a useful tool for creating expressions, such as laughter. (You can also use them to show embarrassment.) Wiping away a tear is a good gesture for big laughers.

When someone laughs really hard, you can create a design element out of it. To do that, write, in cartoony, block letters, the words, "HA HA!" behind the character. Repeat it a few times on the background. Try it on the next page.

Draw the head leaning slightly forward.

Draw a wide mouth and show its interior.

Draw the eyebrows through her hair (the bangs).

Add some motion lines.

draw your own laughing character!

dress the chibis from around the world

Chibis are the small, super-cute characters of manga. They are famous for their intense cuteness. It's almost too much to bear. The chibis in this chapter are going to be so adorable, it'll hurt. Suffer!

Drawing appealing outfits for your characters helps bring them to life. Therefore, I searched the four corners of the globe, in order to find the most brilliant wardrobe for your chibis. I quickly discovered two things: first, the Earth doesn't have corners. Second, there are dazzling wardrobes all around the world, in every culture.

Each drawing exercise is presented across two pages. I'll provide you with all the clothes you'll need to create outfits and scenes for your chibis. (It's like a menu.) You can draw clothes on the chibis on the opposite page. After you finish drawing clothes, draw over the pink lines of the head, features, and hands of the chibis to darken them. Last, add a background from one of my suggestions or invent one of your own choosing.

japan

Konnichiwa! Some of the most eye-catching outfits come from the "historical genre" of manga. Its stories are set back in Japan's feudal age. These characters mainly come in two types: peasants and nobles. It was much better to be a noble. The food was better. The housing was better. Servants were also a nice perk. The clothes were often derived from robes.

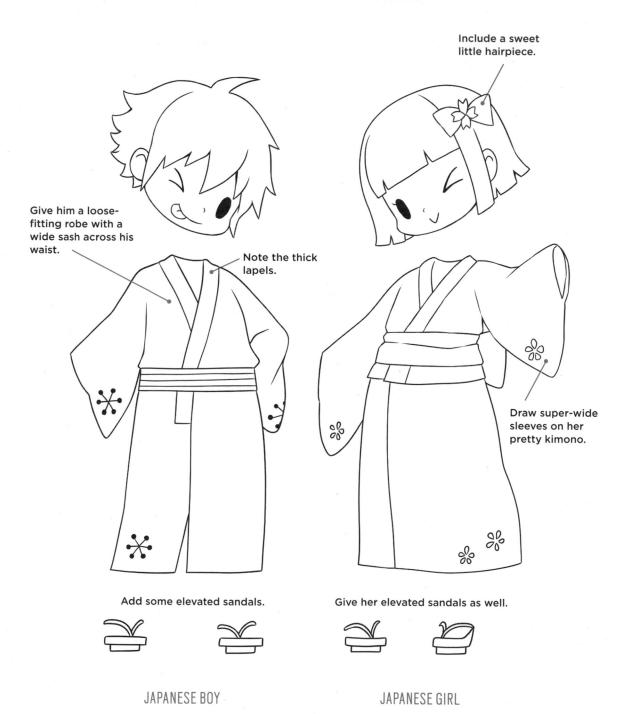

Include a sweet little hairpiece.

Give him a loose-fitting robe with a wide sash across his waist.

Note the thick lapels.

Draw super-wide sleeves on her pretty kimono.

Add some elevated sandals.

Give her elevated sandals as well.

JAPANESE BOY

JAPANESE GIRL

dress up these traditional characters!

THE HOUSE WITH THREE ROOFS WAS
THE EQUIVALENT OF A SKYSCRAPER.

usa

Howdy! In the Wild West of the United States, the town's sheriff could stare down the most fearsome bad guy. A chibi lawman can stare down a bad guy by using cuteness as a weapon. It's not even a fair fight. The gal sheriff also has the "cute" weapon at her disposal.

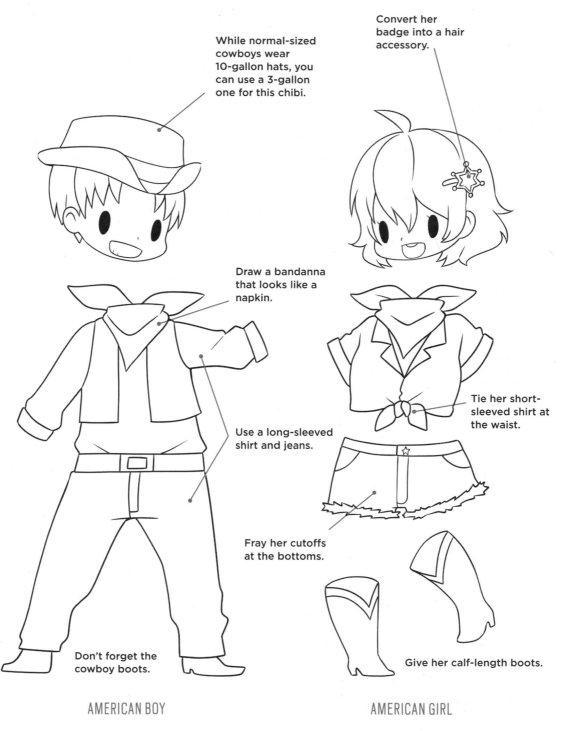

While normal-sized cowboys wear 10-gallon hats, you can use a 3-gallon one for this chibi.

Convert her badge into a hair accessory.

Draw a bandanna that looks like a napkin.

Tie her short-sleeved shirt at the waist.

Use a long-sleeved shirt and jeans.

Fray her cutoffs at the bottoms.

Don't forget the cowboy boots.

Give her calf-length boots.

AMERICAN BOY

AMERICAN GIRL

dress up these Wild West characters

IT MAY LOOK FRIENDLY, BUT PLEASE
DON'T SHAKE THE CACTUS'S HAND!

france

Bonjour! France is famous for the Eiffel Tower and the Louvre. It's also famous for its street mimes, but nobody's perfect.

Ah, springtime in Paris! Love is in the air. Here you have two chibis in the middle of a marriage proposal. Will she say "Yes?" Oh no! I seem to have left out the ring. Be sure to add the diamond ring as you finish dressing them up.

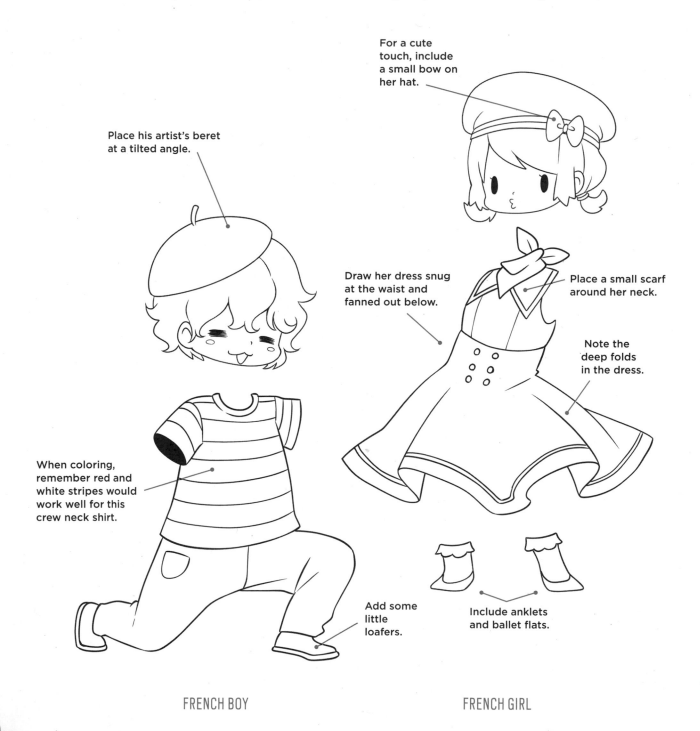

For a cute touch, include a small bow on her hat.

Place his artist's beret at a tilted angle.

Draw her dress snug at the waist and fanned out below.

Place a small scarf around her neck.

Note the deep folds in the dress.

When coloring, remember red and white stripes would work well for this crew neck shirt.

Add some little loafers.

Include anklets and ballet flats.

FRENCH BOY

FRENCH GIRL

dress up these sophisticated characters!

THE EIFFEL TOWER IS AN
EXTREMELY TALL LANDMARK.

scandinavia

Gruetzi! Welcome to Scandinavia! In the countryside, people wear super-cute outfits to traditional festivals. The homes are built Tudor-style, which evokes an Old World charm. These two chibis are wearing proper children's outfits. If I didn't know better, I'd think they were a pair of saltshakers I picked up at the duty-free shop on my last vacation.

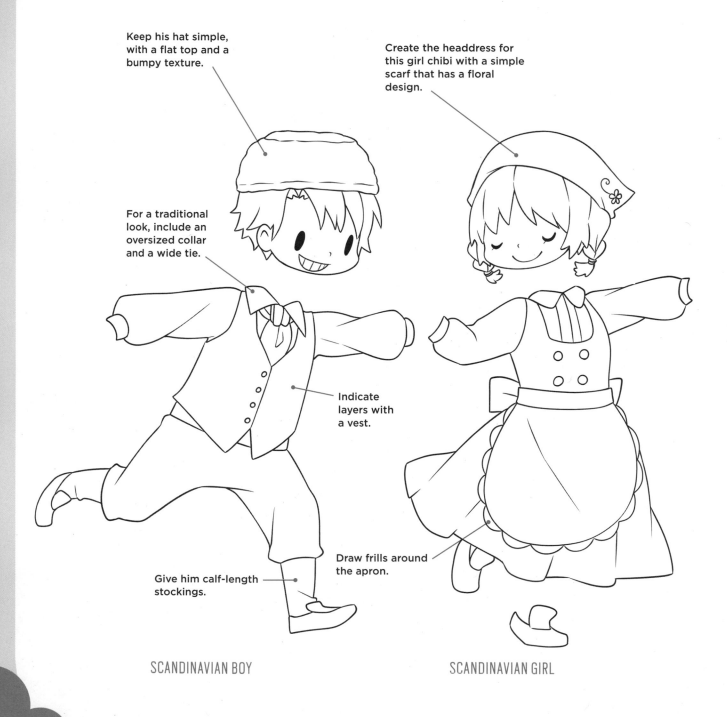

Keep his hat simple, with a flat top and a bumpy texture.

Create the headdress for this girl chibi with a simple scarf that has a floral design.

For a traditional look, include an oversized collar and a wide tie.

Indicate layers with a vest.

Give him calf-length stockings.

Draw frills around the apron.

SCANDINAVIAN BOY

SCANDINAVIAN GIRL

dress up these cute characters!

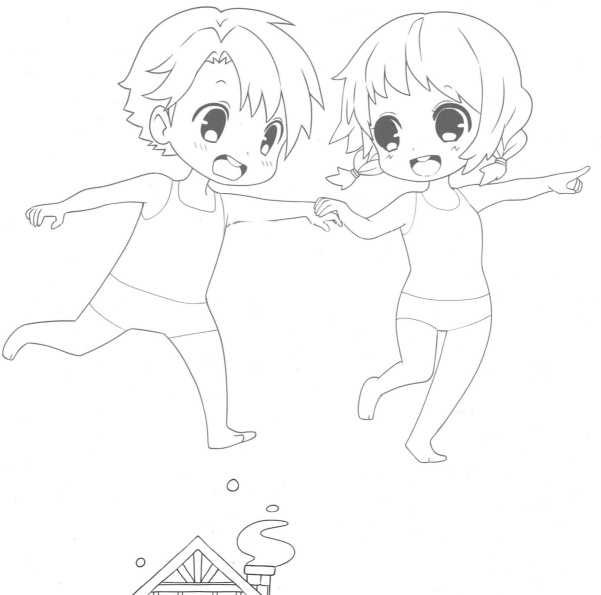

SCANDINAVIAN HOUSES ARE CHUNKY
AND CUTE. DRAW THE WINDOWS WITH
DIAGONAL LINES—SORT OF LIKE WAFFLES!

mexico

Hola! Welcome to Mexico. Here is where you can find one of the seven Wonders of the World: the Mayan Chichén Itzá Temple in Yucatan, Mexico. I believe the Wonders of the World shouldn't stop at seven. Astroturf could easily have been number eight.

Mexican clothing offers a great variety of options, from panchos to full-length dresses to sombreros (the wide-brimmed hat).

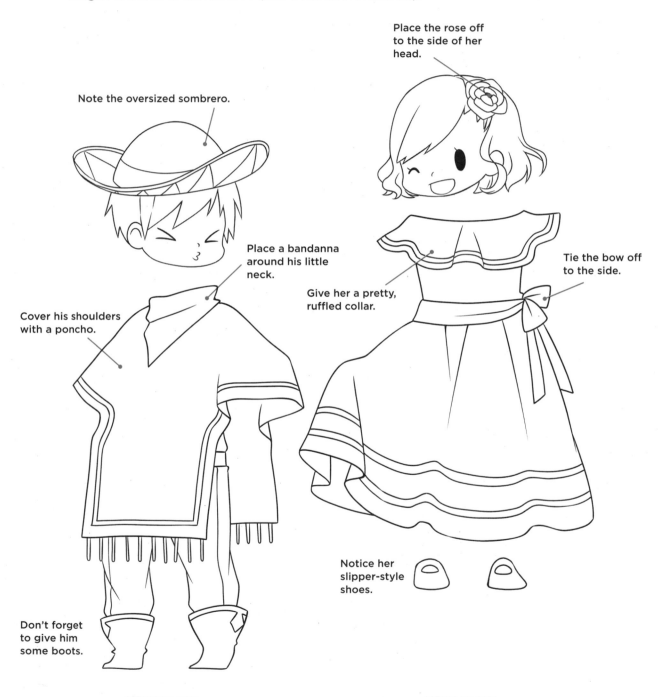

Place the rose off to the side of her head.

Note the oversized sombrero.

Place a bandanna around his little neck.

Give her a pretty, ruffled collar.

Tie the bow off to the side.

Cover his shoulders with a poncho.

Notice her slipper-style shoes.

Don't forget to give him some boots.

MEXICAN BOY

MEXICAN GIRL

dress up these festive characters!

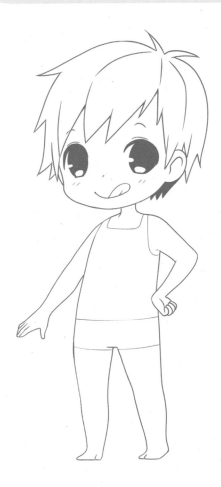

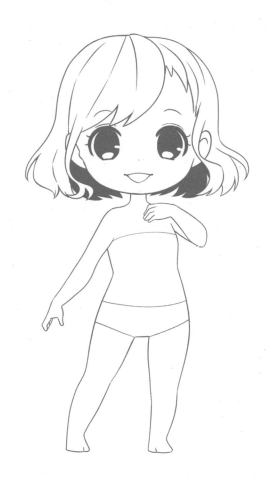

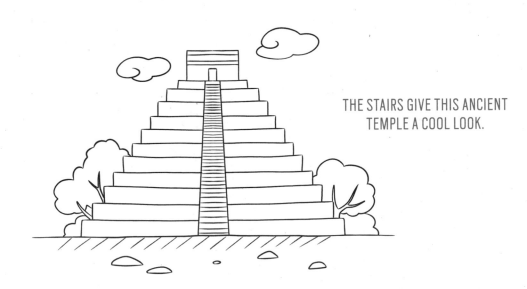

THE STAIRS GIVE THIS ANCIENT
TEMPLE A COOL LOOK.

india

Namaste! These are first-time visitors to the famous Taj Mahal, but they can't agree on what to see first. Traditional Indian wardrobes are silky and ornate. They add a beautiful, fairy-tale mystique to these chibi characters. Elaborate outfits won't overpower your little characters.

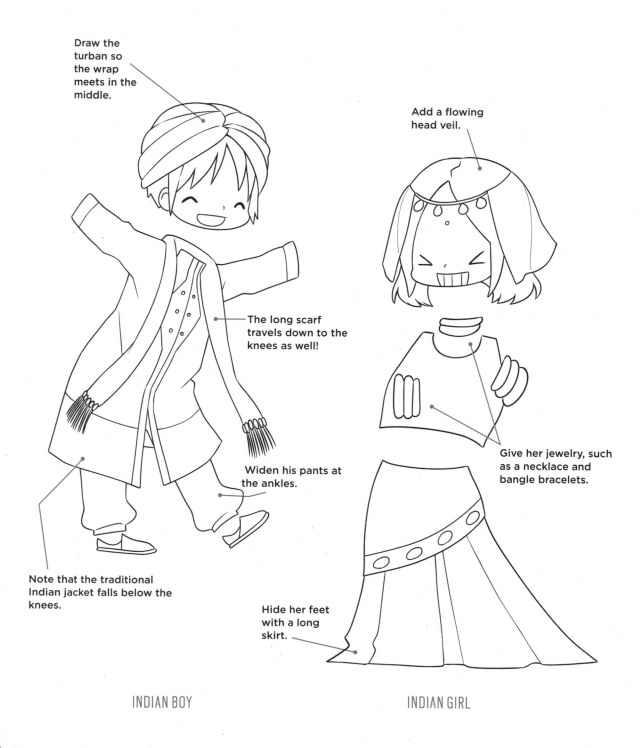

Draw the turban so the wrap meets in the middle.

Add a flowing head veil.

The long scarf travels down to the knees as well!

Widen his pants at the ankles.

Note that the traditional Indian jacket falls below the knees.

Give her jewelry, such as a necklace and bangle bracelets.

Hide her feet with a long skirt.

INDIAN BOY

INDIAN GIRL

dress up these excited characters!

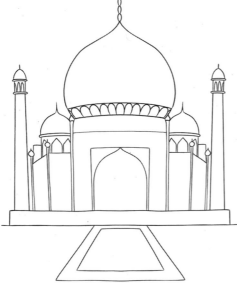

THIS MASTERPIECE IS CREATED WITH SEVERAL IMPRESSIVE DOMES.

tanzania

Jambo! These chibis wear clothing that is generally loose fitting, with brilliant colors and patterns. The boy's cape and the girl's wrap act to shield them from the intense afternoon sun. Drawing a simple pattern on the trim of the outfits add visual appeal. If you're going to try coloring the outfits after you draw them, here's a suggestion: try alternating the colors within the patterns.

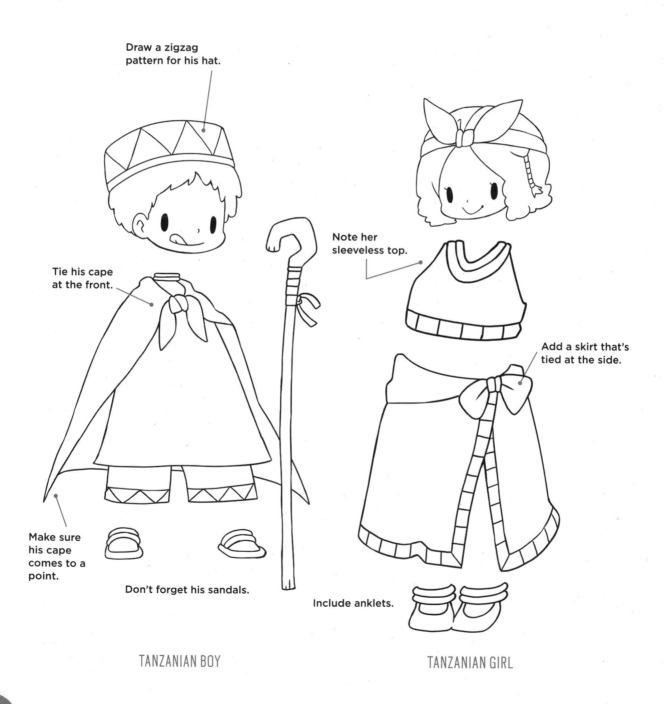

Draw a zigzag pattern for his hat.

Tie his cape at the front.

Make sure his cape comes to a point.

Don't forget his sandals.

Note her sleeveless top.

Add a skirt that's tied at the side.

Include anklets.

TANZANIAN BOY

TANZANIAN GIRL

dress up these friendly characters!

NOTE: THE PLAINS OF THE AFRICAN SAVANNAH ARE WIDE OPEN SPACES WITH AN OCCASIONAL TREE (THAT ELEPHANTS LOVE TO USE FOR BACK SCRATCHES).

draw the super-cute animals

The only thing cuter than a super-cute chibi animal is a super-cute chibi animal in a funny pose. And the only thing cuter than a super-cute chibi animal in a funny pose is a bunch of super-cute chibi animals in funny poses! There's nothing cuter than that. That's maximum cuteness. It's the edge of the charm envelope.

In this chapter, you'll see how to draw these chubby critters. I'll provide several *prompts*—the beginnings of the characters, in humorous poses—which you'll then complete. I hope you can withstand the intensity of the cute attack that's sure to come.

elephant: a ton of cuteness

Start with a basic framework.

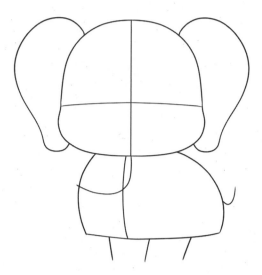

Fill out the body, adding wide ears to the head.

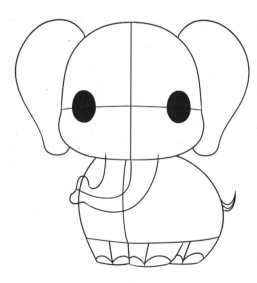

Emphasize thickness for the trunk. Create huge ovals for the eyes. The bigger they are, the more powerful their cuteness is.

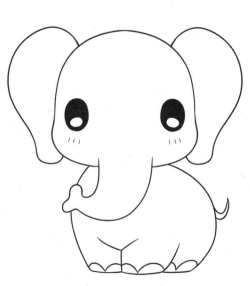

Add a shine to the eyes by erasing an area inside of it. Add little lashes below. Notice that the nails on the feet are big and chunky, like the rest of him. A tiny wisp of a tail makes the character look young.

COLOR NOTE
Elephants are most often colored gray or brown.

posedown!

You can create funny poses, which will evoke giggles from your friends and jealousy from your enemies. Give your characters different expressions. The examples here are only prompts. You can individualize them any way you like. You might want to add clothing or other accessories, such as a cap, a vest, sneakers, a cell phone, a purse, or a wand.

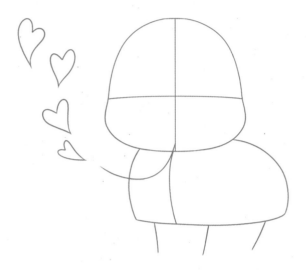

IN LOVE:
Curl the trunk upward to blow hearts into the air.

WITH A COLD:
It's a fact that when you sneeze, you squint. You cannot keep your eyes open. When the elephant sneezes, draw him with closed eyes.

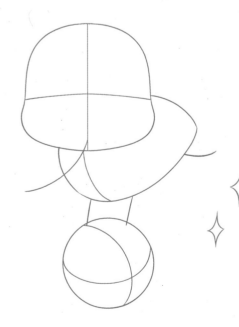

BALANCING ACT:
Draw him with his rear leg off the ball, showing his dexterity. He's really impressed with himself, so draw a proud smile.

chick: fluffy cuteness

Chicks come in two varieties: cute and extra-cute. Let's draw the extra-cute type. On top, draw a round head with fat cheeks and a teensy beak.

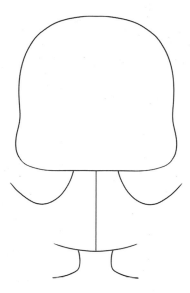

Start with a small frame.

Give him short wings and legs.

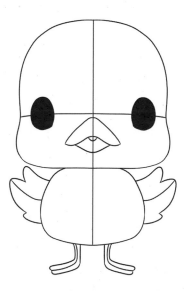

Draw the beak slightly uneven, so the top overlaps the bottom.

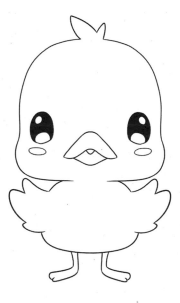

Add a few blush marks to the cheeks, and a tiny tuft of feathers on top of its head. Can't stand any more cuteness? Too bad!

COLOR NOTE
Color the chick a traditional yellow, or use something offbeat—like pink.

posedown!

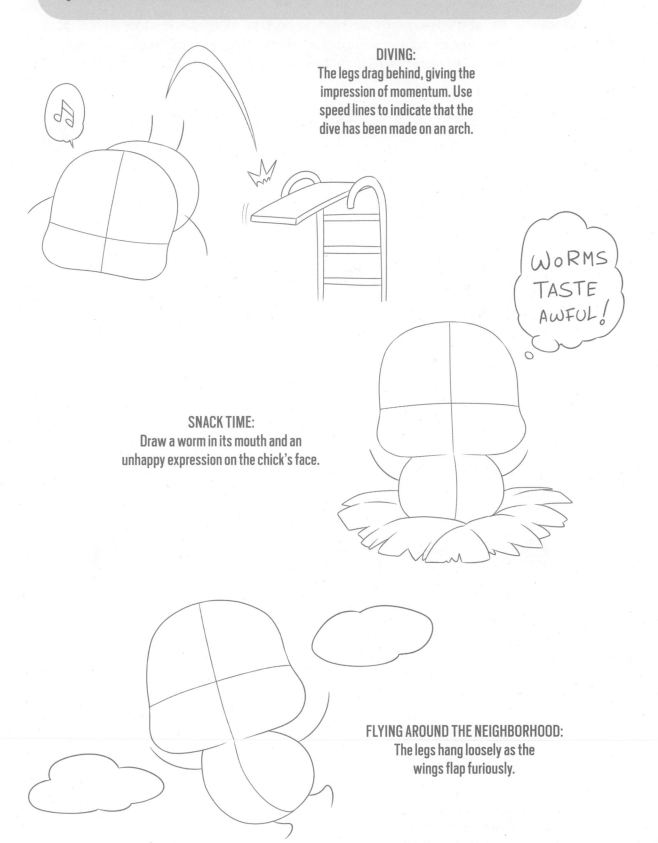

DIVING:
The legs drag behind, giving the impression of momentum. Use speed lines to indicate that the dive has been made on an arch.

SNACK TIME:
Draw a worm in its mouth and an unhappy expression on the chick's face.

FLYING AROUND THE NEIGHBORHOOD:
The legs hang loosely as the wings flap furiously.

hamster: fuzzy cuteness

What is it about hamsters that people find so irresistible? Could it be their big eyes, fluffy cheeks, or squeezable bodies? I just can't seem to figure out what it is. Anyway, the hamster has a wide face, and a body with chubby thighs.

Keep the head round and wide.

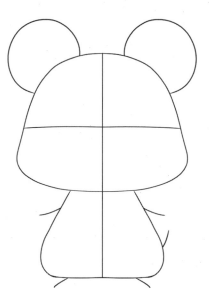

Make him chubby on the bottom.

Give him a "split lip"—a common trait among mammals.

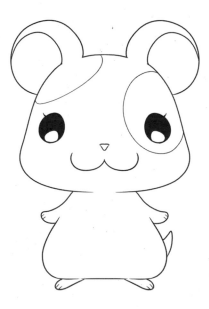

You can add markings to the head, which would be a different color from the rest of the face. Define the interior of the ears.

COLOR NOTE
A good look for the hamster is a combo of tan and white.

posedown!

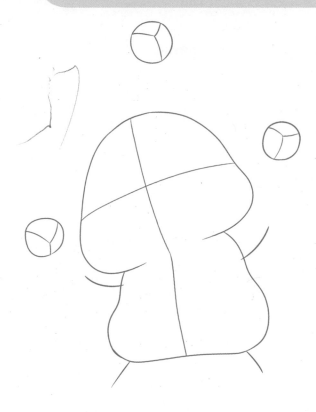

TRYING TO JUGGLE:
Whatever gave him the idea he could pull this off? I'd like to see you draw him with a worried expression here.

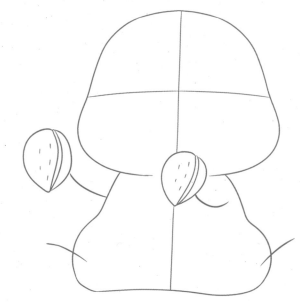

GOING NUTS FOR NUTS:
Draw a tongue out the side of his mouth to show his appetite.

RUNNING ON THE WHEEL:
Give him a sweatband on his forehead. He's worried he'll be late.

giraffe: extra-tall cuteness

Of course, everyone knows giraffes have long necks. But this is a chibi giraffe, which requires shrinking its neck a little. The key to creating appealing images is to approach each detail with the same care as the major parts. Therefore, be sure to draw cute horns, cute ears, cute hooves, and so on.

Draw the neck standing straight up.

Give it a curved back.

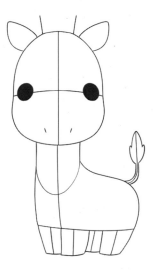

Drawing short legs is a fun way to "chibi-fy" any character. Place the horns between the ears.

COLOR NOTE
Color the giraffe with a light tan, or a cream color. Orange-brown spots work well. But you can also choose funny color combos. Whatever colors you use, it works best if the spot colors are darker than the rest of the coat.

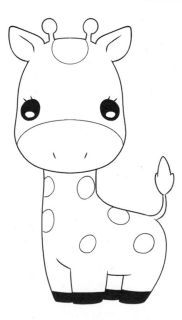

Position the chubby legs together. Add a marking to highlight the muzzle.

posedown!

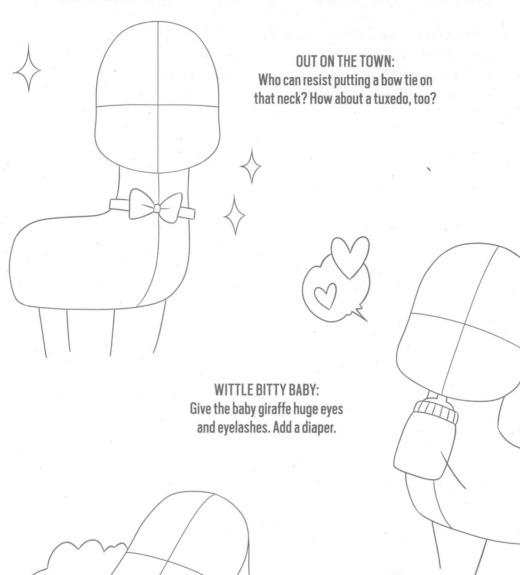

OUT ON THE TOWN:
Who can resist putting a bow tie on that neck? How about a tuxedo, too?

WITTLE BITTY BABY:
Give the baby giraffe huge eyes and eyelashes. Add a diaper.

MUNCH, MUNCH:
This tree could use some balsamic vinegar.

HEY...

pig: chubby cuteness

Although people think of pigs as fat, they are drawn with the same proportions as the other cute animals in this section.

Look at the snout, which is the signature feature of the pig. The ears are also prominent. I am going to keep the cuteness going until you beg for mercy. Just when you think we've reached maximum cuteness, I say we take it a notch further!

Draw the head right on top of the shoulders with no neck in between.

The waist is nonexistent. (And he's not apologetic about it, either!) Make the ears flop forward.

For a funny contrast, use small arms and legs on a bigger body.

COLOR NOTE
Pink is the conventional cartoon color for pigs. However, be careful to use a very light pink. A saturated pink would make the character look too intense (or worse—sunburnt).

Don't forget the famous, squiggly tail.

posedown!

HOMERUN KING:
Draw a baseball uniform on this little athlete. Position the cap at an angle on top of the head.

ATE TOO MUCH:
To show a nauseous expression, draw an unhappy mouth and sleepy eyes.

HELLO, DARLING:
Draw a dashing costume on this pig. If you're feeling adventurous, add his date.

kitten: whiskers and cuteness

People shower cats with affection, food, and toys. In return, if you're lucky, the cat will *permit* you to pet it. The face of a chibi kitty is an oval—with pointed ears and sharp whiskers. Its tummy markings are a popular convention for domesticated animals.

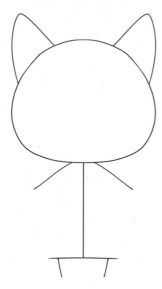

Space the ears far apart.

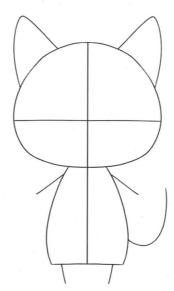

Draw short legs, so that this character looks cute, rather than gangly.

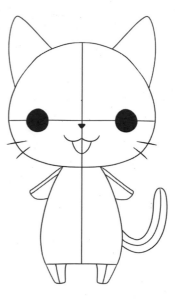

Space the eyes very wide apart as well. Make the limbs short, but plump.

COLOR NOTE
The traditional colors for manga cats are gray, white, and beige. The tummy marking can be white or slightly off-white, and the inner ears can be light pink or peach.

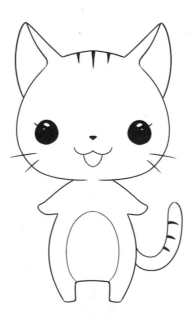

Stripes are a good marking for tabby cats. But you could use spots, instead.

posedown!

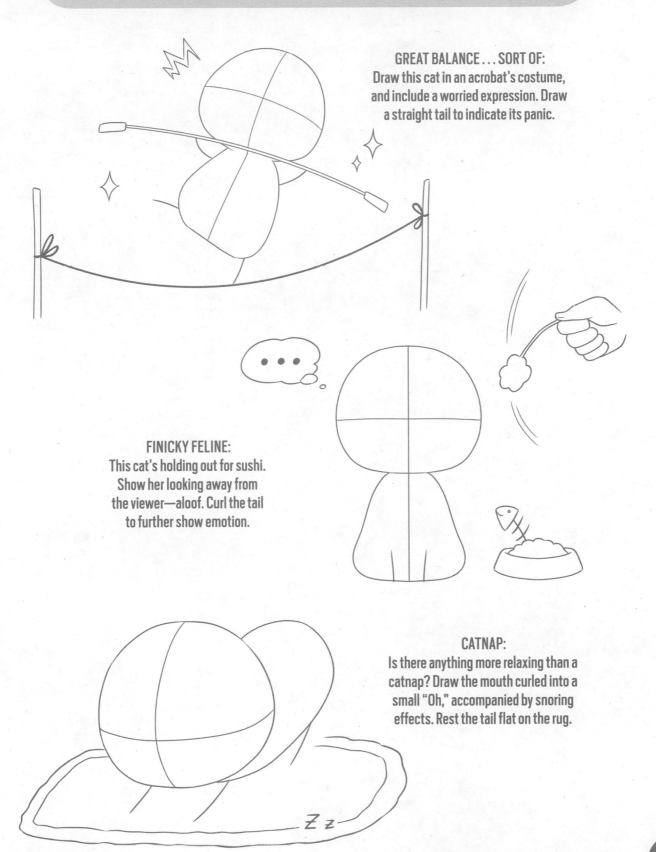

GREAT BALANCE . . . SORT OF:
Draw this cat in an acrobat's costume, and include a worried expression. Draw a straight tail to indicate its panic.

FINICKY FELINE:
This cat's holding out for sushi. Show her looking away from the viewer—aloof. Curl the tail to further show emotion.

CATNAP:
Is there anything more relaxing than a catnap? Draw the mouth curled into a small "Oh," accompanied by snoring effects. Rest the tail flat on the rug.

add a team leader

In a cast of characters, there are supporting characters, and then, one leader in the starring role. In manga, which is an illustrated medium, there are specific ways to demonstrate who the leader is. Positioning the leader at the front of the pack is one way to show his or her status in the group. You can also draw the leader taller than the other characters. Leaders can make a statement with a pose and may use more interesting props than the supporting cast. Lastly, the leader is sometimes drawn with more details than the supporting characters.

In this chapter, the characters are drawn as members of a group. The supporting characters are finished. But you'll complete the characters in the starring roles. Therefore, your artistic contribution will be the highlight of each section.

state champs!

Even without the details in place, you can tell the character in the center is the star basketball player. First of all, she's the one with the ball. Her stance is self-assured. She is drawn taller than the other characters, and is situated at the front of the pack.

This character type is usually drawn with a confident grin. Be sure to draw her uniform so that it matches that of her team members.

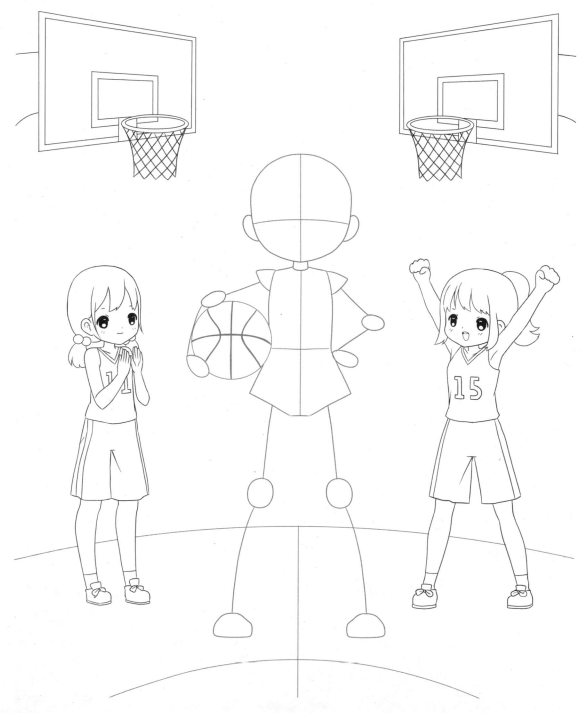

reporting for duty

Draw the commander, in the middle, leading the troops in a salute. Military uniforms are form-fitting, well-starched, and crisply pressed. However, manga artists like to take a few liberties. For example, the haircut on the soldier at right is not what you would call "regulation."

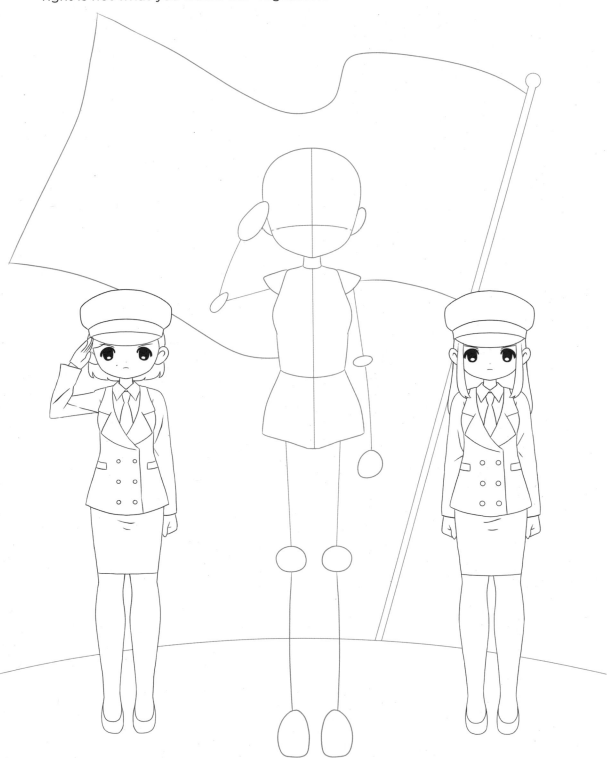

dash for a splash

The lead character can also be the one who gets the big laughs. In this scene, the supporting players are getting ready for a dip in the ocean. But the main character, positioned in front, has already tested out the water. How is it? Draw a grimace and add motion lines around the main character to show that she's shivering.

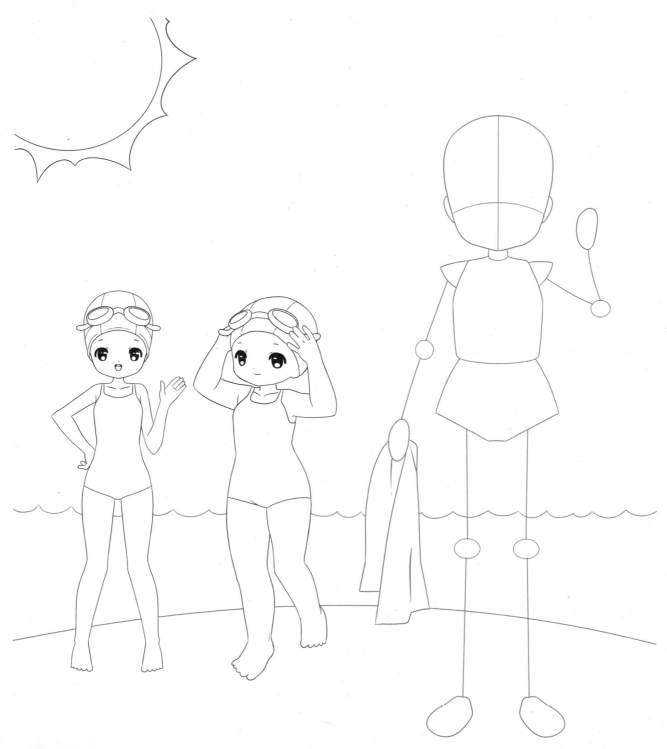

cute maids

In Japanese comics, glamorized maids are as pervasive as pop-up ads on your browser. *Pretty* and *frilly* are the keywords for these characters. You can also draw fancy hairpieces, skirts, aprons, collars, and ribbons. These maids wear such expensive clothing that no one makes them actually do any house-work. Maybe that was their plan all along.

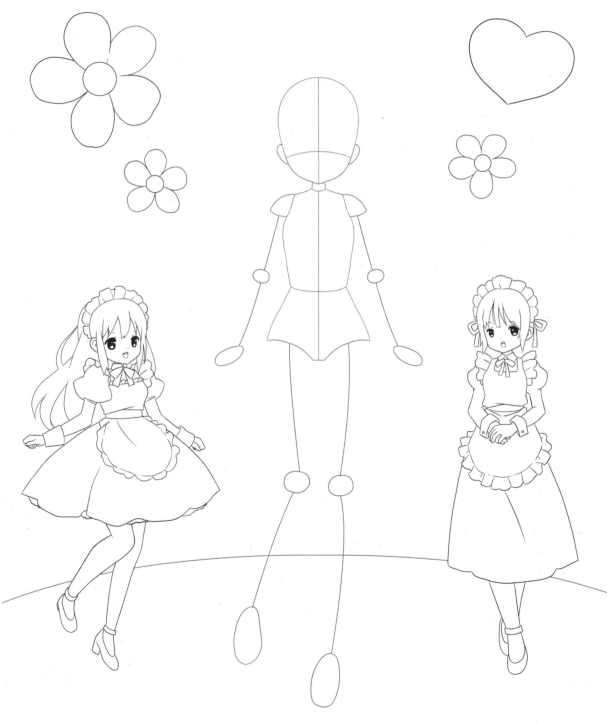

greedy capitalists

No one is saying that greed is a positive thing. It's bad. So, so bad. But there's no arguing that a Maserati, a Swiss ski lodge, and a yacht are fun to own. The CEO in the middle of this company team is a ruthless leader. His favorite sport is firing staff members just before Christmas. It's your choice whether you want the leader of this group—a corporate titan—to be a female world-beater or a male rainmaker. Give the corporate chieftain a snarky smile.

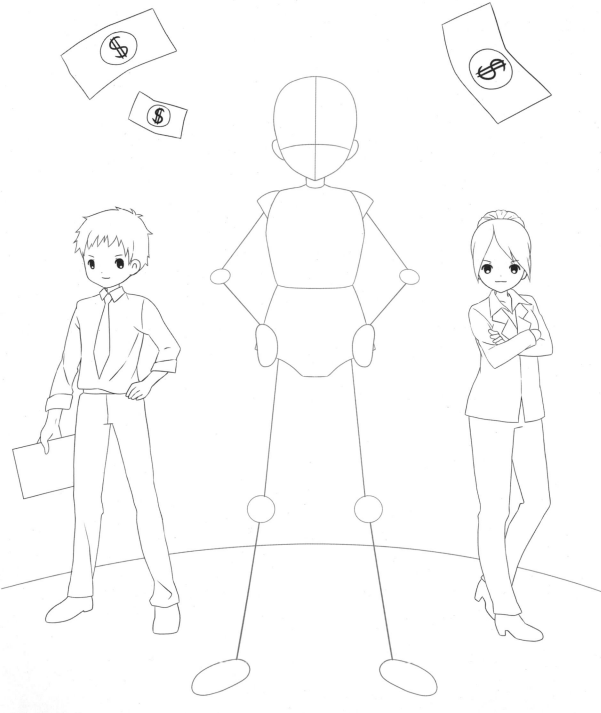

our hero

Everyone needs a hero. For kids, it's often a sports star. For teens, it may be a rock star. For adults, it's the tech guy who can get the computer running again. But if you're living in a world of fantasy and darkness, where monsters roam, then a hero is very, very useful. First of all, heroes fight monsters. Second, they usually work for free.

This female warrior is a teen character. If you want to get fancy, draw a large shadow on the ground, so that it appears that a monster is approaching her.

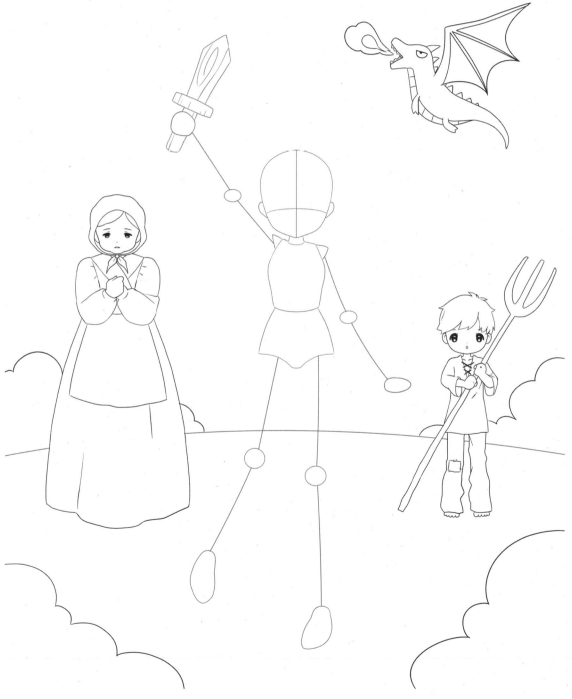

puppy iditarod

They're not exactly the strongest looking dogs on the planet. But how much strength do you need to pull a chibi over a snowy trail? A chibi weighs about as much as a bowl of jelly beans. That's a fact. I checked the manual.

 You can vary the marking of your pups. Or, you can leave out the markings in order to make them white huskies. If you want to make the picture even funnier, draw the tongues of the dogs flopping out of the sides of their mouths.

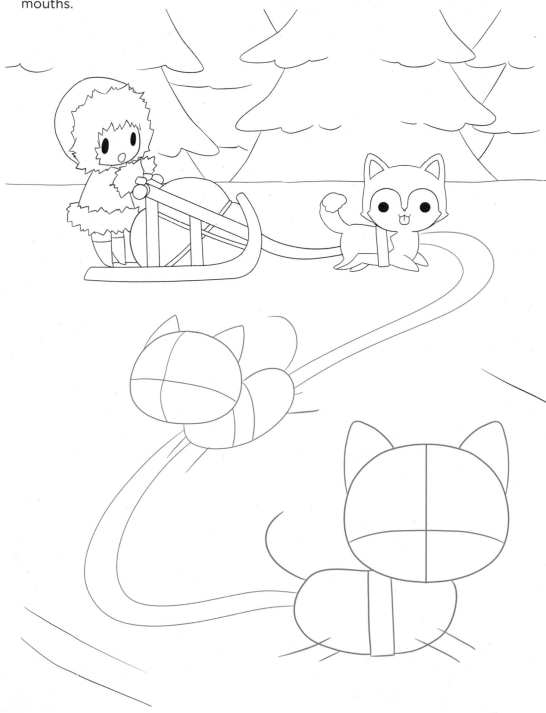

vampire party

What do you wear when attending a vampire party? The answer is a very, very high collar. If you don't have that, I suggest wearing some garlic cologne. If you don't have that, I recommend turning down the invitation.

You can color your vampire drawings. But gothic creatures, especially vampires, look good in black and white. I recommend drawing the leader with a half-cape, for a cool look. It cuts off around his thighs. Draw a thick sash around his waist. Long hair also distinguishes him as the leader, the most charismatic vampire in the castle.

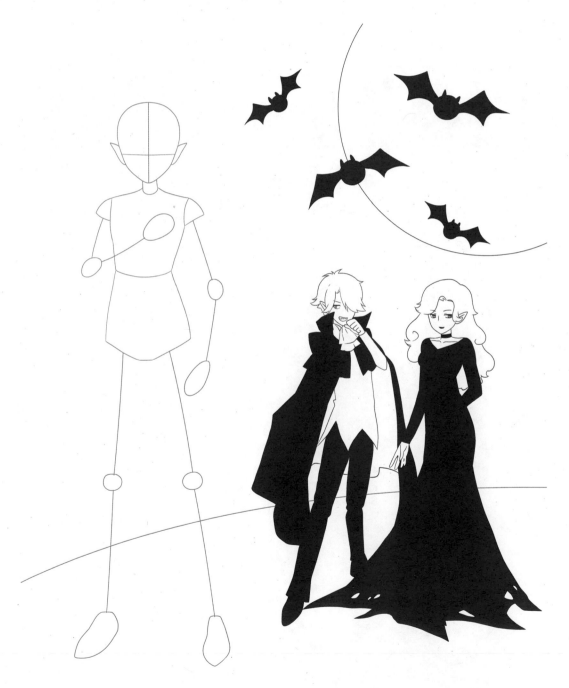

have fun with emoticons

You've seen them all over the Internet and on your smartphones. Popularly referred to as *emoticons* or *emoji*, these adorable symbols are a great way to convey your current mood or reaction to something. Manga emoticons are both simplified and exaggerated. I'll kick off this chapter with two reference pages filled with hilarious, popular emoticons. This will give you an idea of how exaggerated to make your own. Next, you'll get a series of pages that have blank faces for emoticons, but no expressions. Guess who's going to fill in the expressions? Yep. I've added a label below each face to indicate the expression to be drawn.

try out these funny expressions . . .

Cheerful laugh

Eager smile

Ouch!!

Oh dear!

Don't try it!

Gushing tears

Sleepy

Surprised

. . . and these silly looks, too!

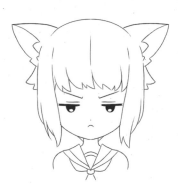

Suspicious

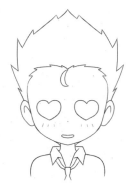

Infatuated

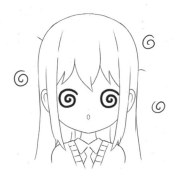

Oooooh! Me want!

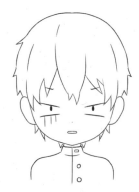

Confused

Knocked out

Bwaaaaa! Not fair!

Tiny giggle

Hee-hee!

standard headwear

PETITE SMILE
Draw blush marks.

SO COLD!
Add snowflakes.

JUST CHILLIN'
Add a musical note near his earphones.

BLOWING BUBBLE GUM
Draw big cheeks and add a
shine on the bubble gum.

un-standard headwear

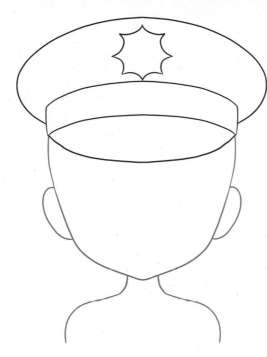

STERN
Add a squint.

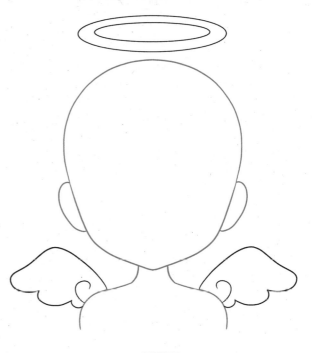

SWEET
Draw giant pupils with big
shines and little eyelashes.

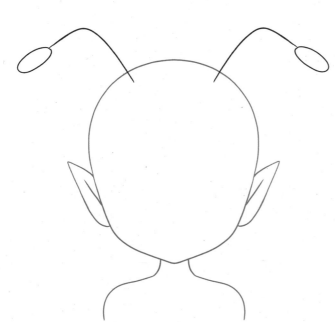

MISCHIEVOUS
Give this fairy tapered eyes.

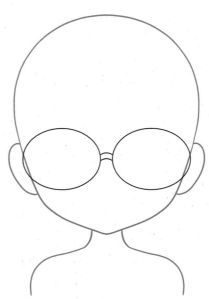

GENIUS
Write an equation, like
"$E=MC^2$" over his head.

funny touches

PLAYFUL
Give her whiskers and
big front teeth.

DEMANDING PRINCESS
For a funny effect, add a huge
mouth giving an angry yell.

WICKED
Draw him looking directly at the viewer
with evil eyes and a small smile.

MYSTERIOUS AND GOTHIC
Draw this fellow with a little
shading under his eye, a small scar
on his cheek, and spiked hair.

define the character

CONFIDENCE
Draw this cowboy chewing
on a piece of straw.

MAGICAL
Draw this magician with a little smile,
swirling hair, and tiny stars above her.

FRIENDLY
Use a wink here.

ACHING
Draw a small "pain star" over him, with a
squiggly line traveling back to his head.

stuff the pages with doodles

Because doodles are generally small, you can stuff, squeeze, and pack a bunch of them onto a single page. When you fill a space with many small icons, something interesting happens. You end up with an overall design, that is eye-catching and fun to draw.

Each section in this chapter has a theme, such as "manga animals" or "funny, inanimate objects." The beginning of the design appears on each page. You'll complete the page by repeating those icons. You can add your own ideas for humorous icons. I'll also make suggestions for more images.

To create appealing, tiny manga icons, remember these four hints: make them small, make them simple, make them chubby, make them round. But most important: have fun!

cute things

Bet you never knew that houses, drums, and gumball machines had so much personality. In the cute world of manga, any object can come to life—with faces and personalities. The random selection of cute images keeps this page interesting. Repeat these icons until the page is stuffed with drawings. Here are suggestions for even more images you can add: a mailbox, a hocket stick and puck, a toaster (with waffles), a fire hydrant, and an alarm clock. Give each one a face and an expression.

animal stuffers

Animals generally stay with their own groups. Penguins with penguins, koalas with koalas, chipmunks with chipmunks, and so on. They live in different regions, even on different continents. It would be wacky, preposterous, and insane to group them all together on a single page. So let's do it! Here are suggestions for more animals you could add to complete the design: a turtle, a narwhal, a stingray, a chimp, a sheep, a frog, a deer, and a rhino.

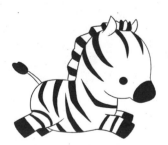

yummy treats!

This page is filled with so much sweetness, it will turn your brain into candy corn. You can add a variety of your own edible delights to the design including a 7-layer cake, chocolate chip cookies, candy apples, fruit tarts, funnel cakes, a jelly roll, cotton candy, and a serving of flan on a small plate. Here's a hint: if you tilt the images slightly, it will give the characters a more energetic look.

weird weather

Outside of manga, there aren't very many friendly looking hurricanes and tornadoes. Many of these icons are drawn as if they were in motion, which adds another dimension to your doodling. Add attitudes that fit the characters. For example, the swirling tornado looks seasick from constantly spinning. Here are some additional weather icons you can use: a cloud with snowflakes, a compass or a barometer, wind (depicted by branches of a tree leaning in one direction), a moon wearing a nightcap and winking at the viewer, and a bunch of icicles.

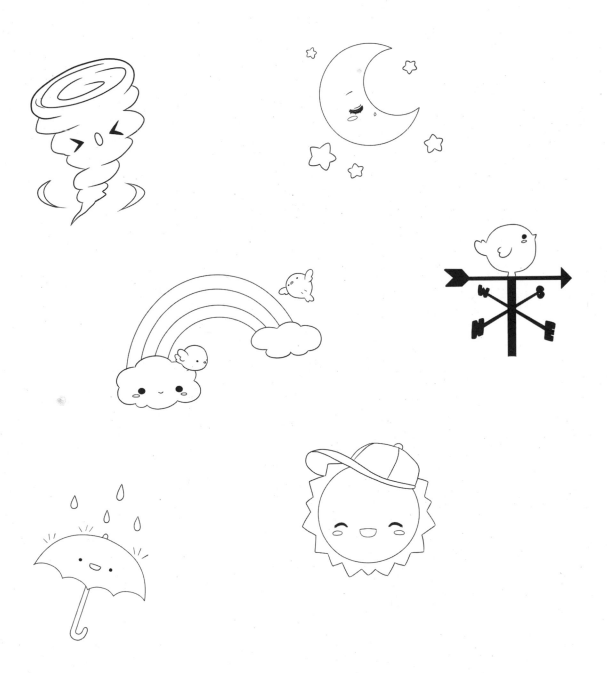

tiny romance

Nothing says "I love you" more than a rose and a wedding ring. Except, maybe, a bigger ring and a whole slew of roses. Here you'll find everything you need to create a greeting that says "You're special to me." More drawings for your lovey-dovey design could include: a puppy with a collar and heart-shaped tag, a stuffed rabbit holding a heart-shaped box of chocolates, an arrow with a heart-shaped tip, a T-shirt with two overlapping hearts printed on the front, a necklace with a string of tiny hearts, and a cupid hugging an oversized heart.

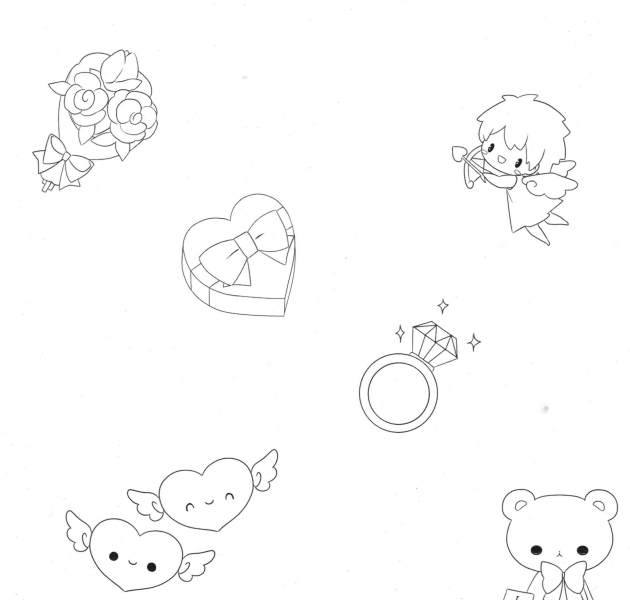

mini vehicles

I'm skeptical as to whether these vehicles are street legal. But I'm sure they're fun to ride. Most vehicles are drawn with ruler-straight lines. Not so the cars, planes, and other cute vehicles of manga. They're drawn with curved lines. They should look compact, adding to their cuteness. Here are some more ideas for items to fill the page: a tank, a cruise liner, a tram, a school bus, an 18-wheeler, a train, a cop car, a sailboat, a hot air balloon, and a starship.

winter fun

Draw whatever it is about winter that you enjoy. Maybe it's a group of caroling chibis, or something sillier, like a squirrel on a pair of tiny skis. Maybe it's two people, sharing a sled. Whatever it is, draw your version for the season. Here are a few additional suggestions: ice skates, mittens, evergreen trees with snow on the branches, a cup of steaming cocoa, a knit hat with a pom-pom, a snowmobile, a bell with a ribbon on it, and a fireplace with a fire.

fantasy time

Fantasy is a combination of fun and wonder—with a bunch of wings, horns, and capes tossed into the mix! Meanwhile, here are a few suggestions for other fantasy types you can draw, in addition to the ones that are already on the page: a monster, a wizard, an enchanted knight, a zombie, a ghost, a skeleton in a Viking helmet with sword and shield, a gremlin, a wand with small stars trailing from it, a mini-castle, and a baby goblin.

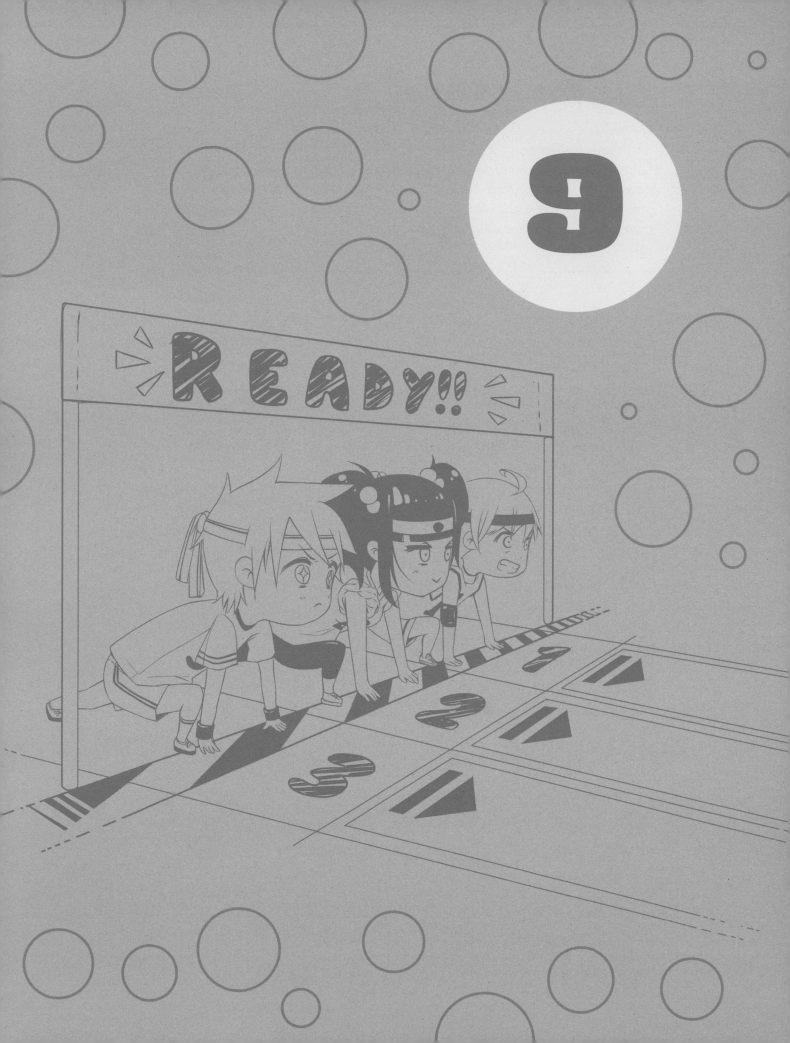

master the manga mazes

Welcome to the wacky world of manga mazes. Each maze in this chapter starts with a humorous scene. This scene leads into a pathway, which you'll extend into a maze.

You'll continue the pathway onto the next page, finishing at the bottom of the page on another funny scene. Each maze is peppered with fun obstacles. You can draw your maze around the objects or even encircle them. Use false starts and stops, zigzagging, and kooky lines. The point is to make each maze as frustrating as possible for anyone foolish enough to attempt it. Be diabolical.

follow that hose!

This is either a manga maze or the longest fire hose in history. With your drawings added to the page, it'll be both. But this is urgent. The chibi fireman has to attach his hose to the fire truck on the next page, if he has any hope of putting out the fire on the birthday cake! Help our hapless hero navigate the obstacles, and draw the hose so that it reaches the truck.

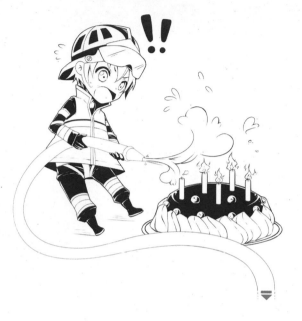

Connect the end of your maze to the hose on the fire truck, so the chibi fireman can squelch the birthday candles. After you have saved the day, have a slice of the ice cream cake as your reward. Unless it's melted. In which case, have some ice cream soup.

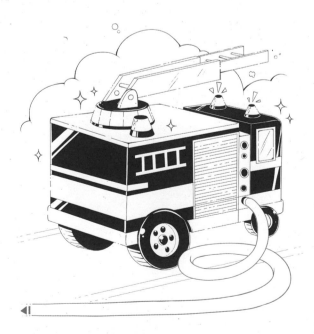

mad dash for a splash

Water parks are all a maze of tubes, winding around and finally swooping into giant tanks of water. At the start, you see three intrepid belly floppers about to take the plunge. Their starting tube quickly divides into three paths, giving you more options for drawing the maze. You can go crazy drawing paths that seem to go forward, only to end up traveling in reverse. Eventually, you've got to link the tubes back into a single chute that leads to a tsunami splashdown on the opposite page.

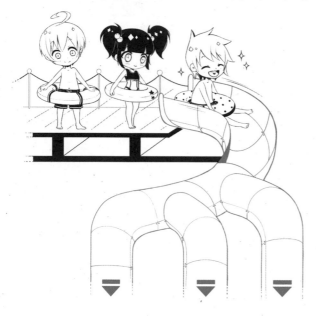

Bring your maze to an end at the tube below. The object of this maze is to let the swimmers make the biggest splash possible—right in the direction of their parents!

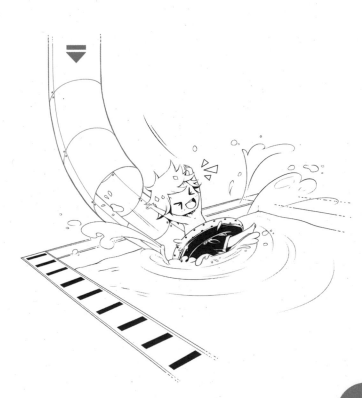

go for the gold

This little group of friends has decided that traveling down a mine shaft to hunt for jewels deep inside the Earth is a great way to get rich. That sure does sound like the easy road to success! Before they began, our treasure hunters carefully checked to make sure they had all the right clothes and gear. Too bad they didn't check to see if the cart they were riding in had brakes. Draw a wild ride across the pages here, and hook up to the rails at the bottom of the right-hand page.

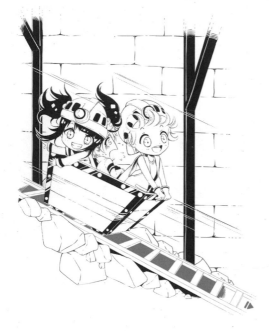

The mine shaft ends deep underground where there are gems worth 10 billion dollars. Want to know what the mine overcharges to get back up to the surface? 9 billion!

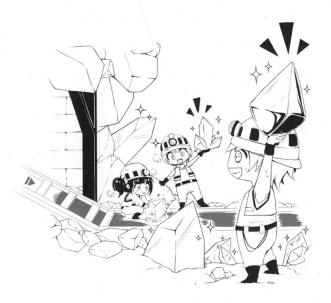

hitting the slopes

I sense a high-speed face-plant coming! I'll bet you five bucks that these snowboarders end up crashing through the front door of that lodge (on the next page). Draw the trails crisscrossing down the mountain. And don't hit any trees on the way down. *Ouch!* You could also add snowflakes. And of course, don't forget to scatter a few lost hats and ski poles, too.

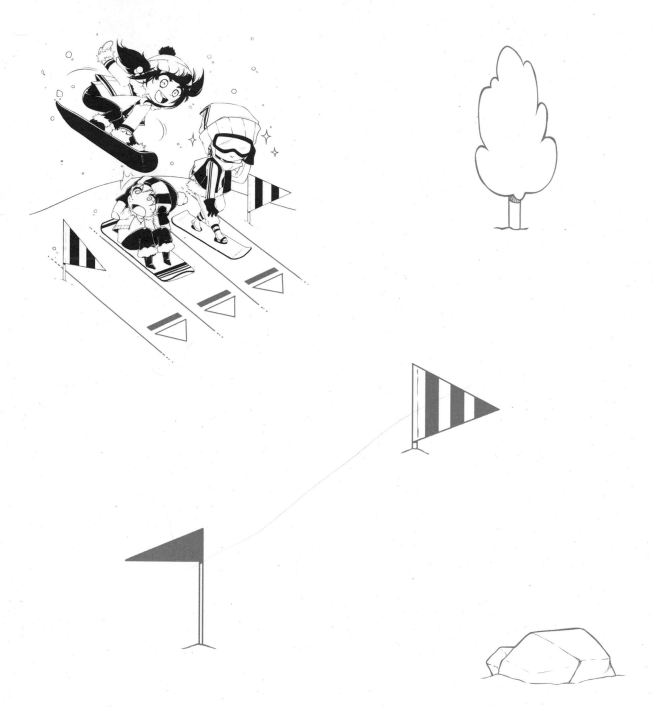

End your maze at the cabin and have the characters step in to get warm.

who's for dinner?

The only hope these chibis have of staying alive is to make it to their boat before the tiger can catch them. Once they take off down the river, they'll be safe, provided that they don't run into any crocodiles. Or water snakes. Or piranhas! Maybe these explorers could use a plan B. In this jungle environment, you'll want to draw weeds and stalks at the edges of the trail, so that it doesn't look neatly landscaped.

The chibis have made it to the boat! But wait. They get seasick. (Ever have one of those days?)

on your mark, get set, slow!

Do you have any idea how long it takes the average chibi to run a mile? We're talking weeks! Even slower, if no one is chasing them. Marathons generally take place in cities, and therefore, this is a road race. To make the path look like a sidewalk, draw the maze with straight lines, sharp turns, and right angles, instead of curves. Draw lines inside of the path like a series of squares to create the look of sidewalk squares.

Draw your maze so that it ends at the finish line. Whew! I've never seen chibis run three blocks so fast. Fist bump!

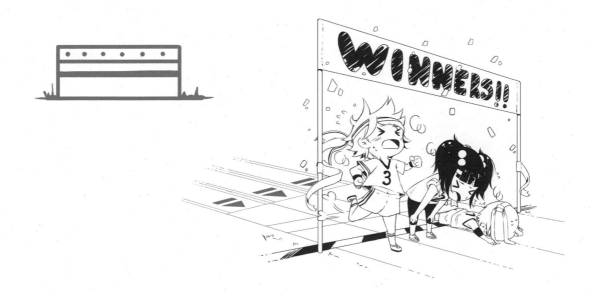

complete the scenes

Drawing individual characters is a lot of fun. It's even more fun to draw them in an actual scene with a background. It can be challenging, since there are many elements that go into staging a scene. That's why this chapter gives you a head start with partially provided finished scenes. You get to draw the rest of them. Try to keep the look of your characters, and outfits, consistent with each other, so that they appear to belong in the same scene together. You'll complete the facial features, hairstyles, expressions, and outfits any way you like. When you finish, you'll have a completed scene. You can shade it, or color the entire page, which will give it maximum impact. There are a bunch of humorous setups for you to enjoy.

beware: student skater

Ice skater collisions tend to spread like pins after a bowling ball knocks into them. Draw the fallen skater with spiral eyes to show her dizziness. Don't forget the ruffled hair. Finish the characters with scarves, jackets, mittens, skates, and knit hats.

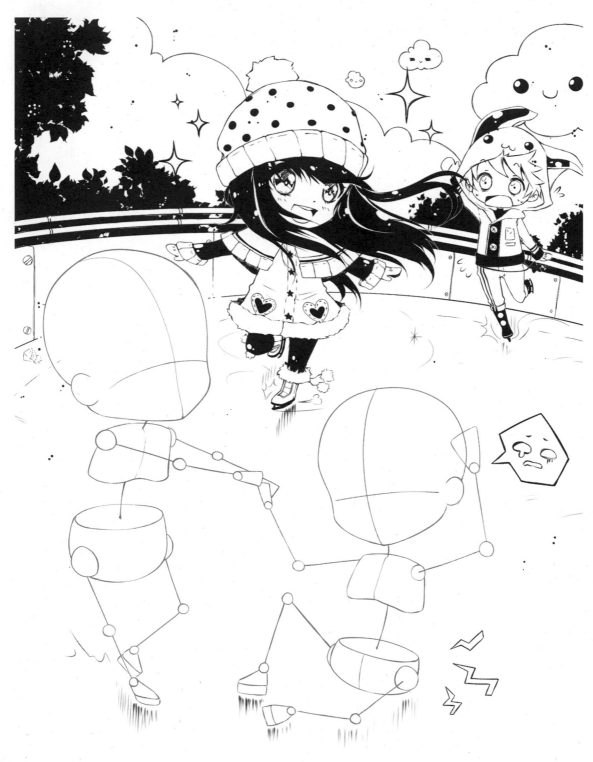

poolside

The more "stuff" you can pack into a swimming pool scene, the funnier it will be. Floating chairs, inner tubes, styrofoam boards, and volleyball nets can turn a swimming pool into a playground. You can add a snorkel to the unfinished character at poolside or a sun hat to the character lounging on the inflatable chair. A funny addition would be a fish looking at the swimmers as if to say, "What are they doing here?"

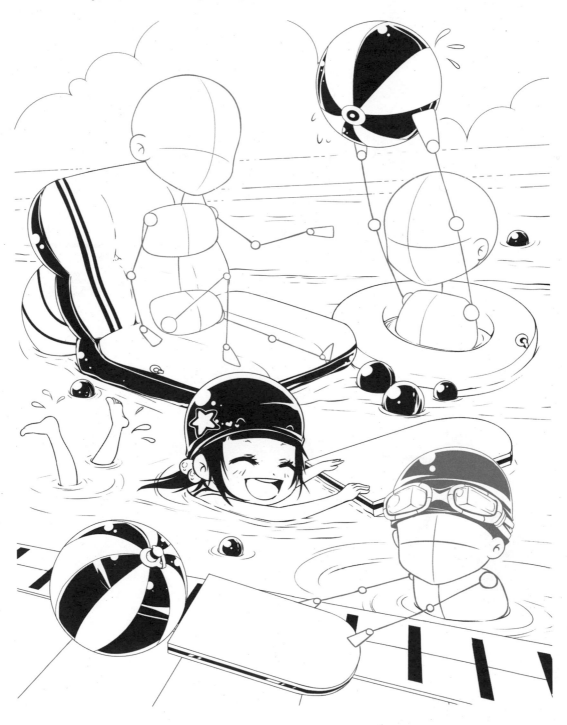

huffing and puffing

No matter how hard they train, chibis will always appear round and cute. It's funny to show chibis working out hard because nothing will come of it! Draw small mouths on these figures, forming little "O's," to show that the characters are puffing out small bursts of air with every exhalation. Add sweatbands and leg warmers to the workout outfits as well.

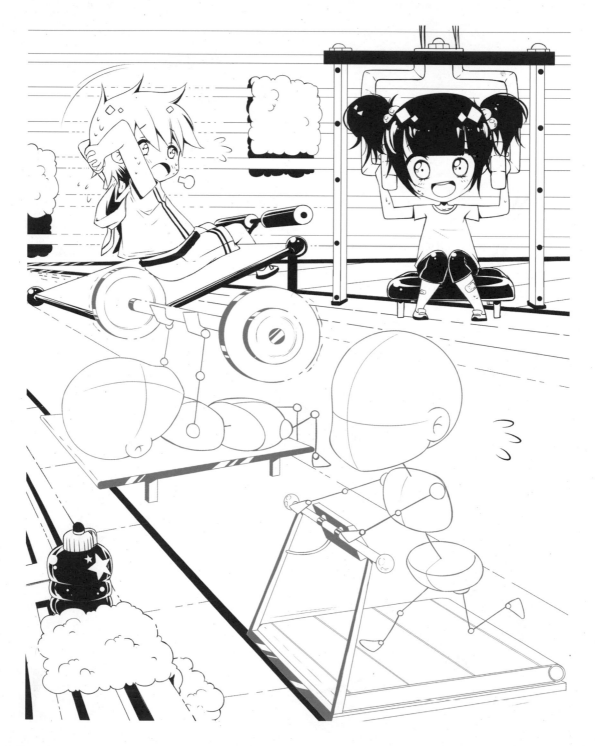

trophy winner

She's the captain of the winning team, so draw a medallion hanging from a ribbon around her neck. Write the phrase, "1st Place" on the trophy itself. A soccer outfit should have a matching top and shorts, knee-length socks, and athletic shoes with cleats. And draw alternating black-and-white geometric shapes on the soccer ball under her foot.

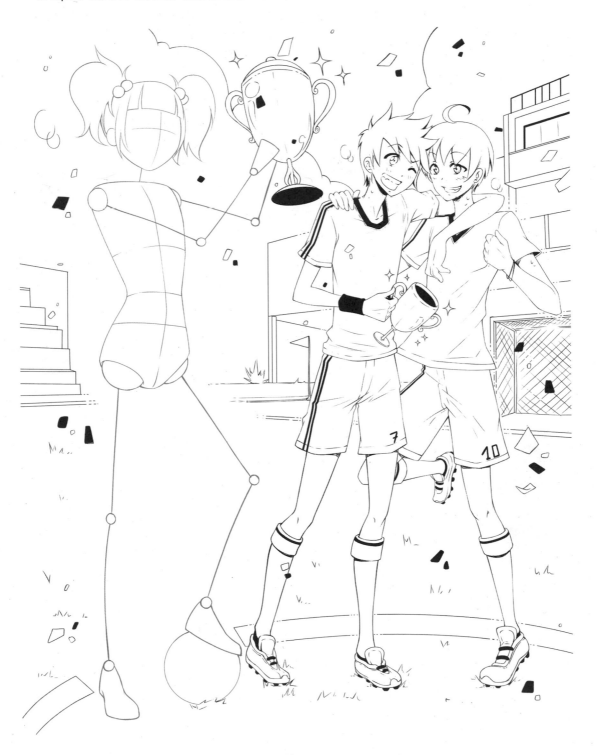

first date

He's wrapped up, paying attention to the movie, rather than his date. To make matters worse, she's not loving his choice of film—a story about robot zombies! To make matters worse than *that*, he's hogging all the popcorn. Notice the bulging blood vessel on the side of her head? That means she's thirty seconds from a total meltdown.

Draw the tub overflowing with popcorn. Draw his mouth with bulging cheeks. Her lips should be pursed around her straw.

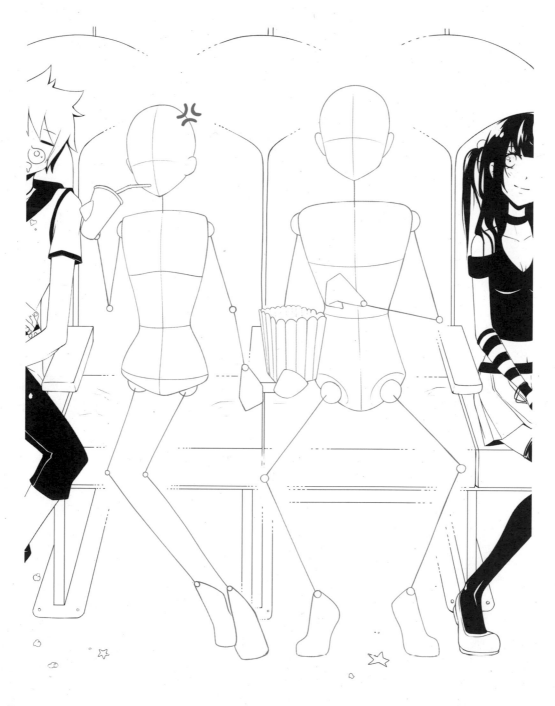

a haul from the mall

Let's see, are there any shops these characters overlooked? Nope. Is there any credit left on their dad's card? Nope. Are they going to be able to explain why they need all the stuff they bought? Nope. Give them big smiles as they carry their loot home.

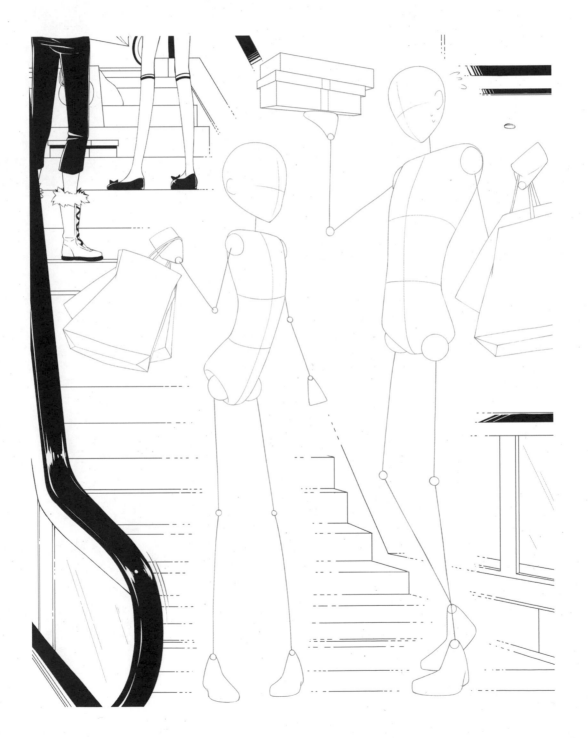

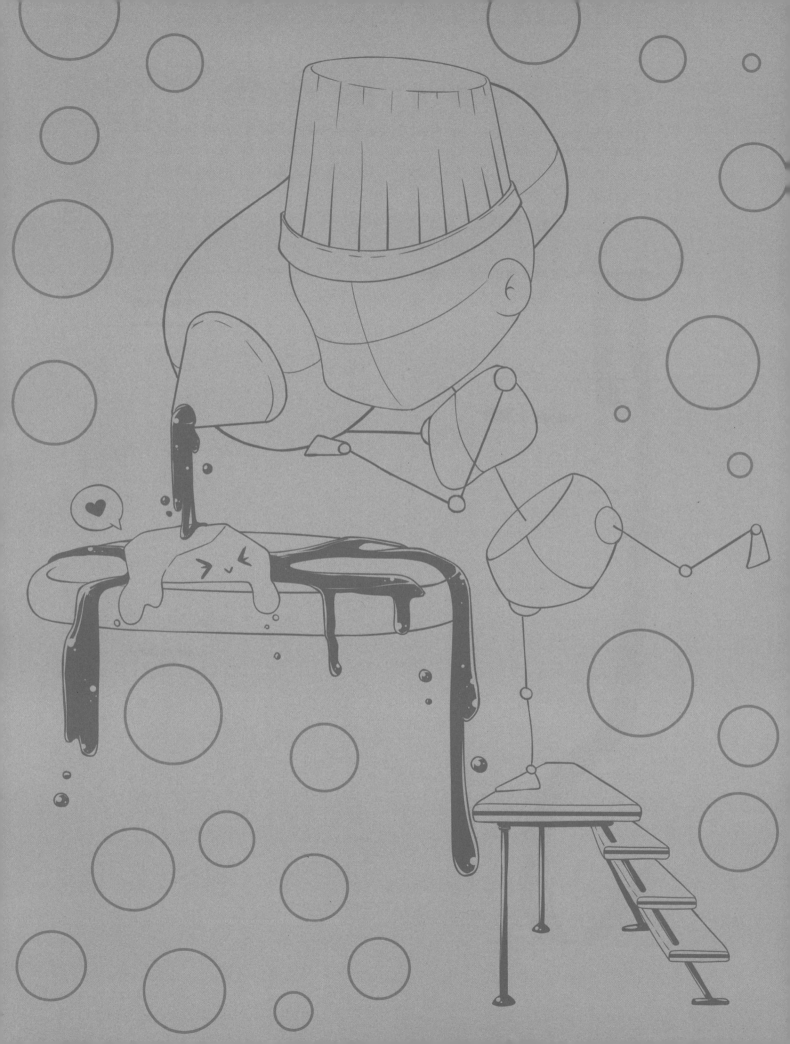

what's cooking?

Cooking has emerged as a big genre in manga. Why not? There are a zillion cooking TV shows, including everything from shows about restoring restaurants to cooking competitions to food tours throughout the country. The cooking genre has several things going for it: the uniforms, the specialties (baker, hibachi chef, and so on), and the artistic culinary creations.

Cooking also gives your characters a fun activity to engage in, one where anything that can go wrong will. These chef characters are all chibis, which means that the stove, utensils, and other props tend to overpower them, creating humor. Go ahead, draw a few of these manga chefs, but try not to let your characters make a mess in the kitchen.

stir fry fiasco

Think it's done yet? Not the food. I mean the hat. Someone should issue permits for this type of activity.

At least this chef is brave. Braver still will be the customer who tries out the resulting dish.

HINT
Draw the eyes huge—just like the mouth—for a shocked expression.

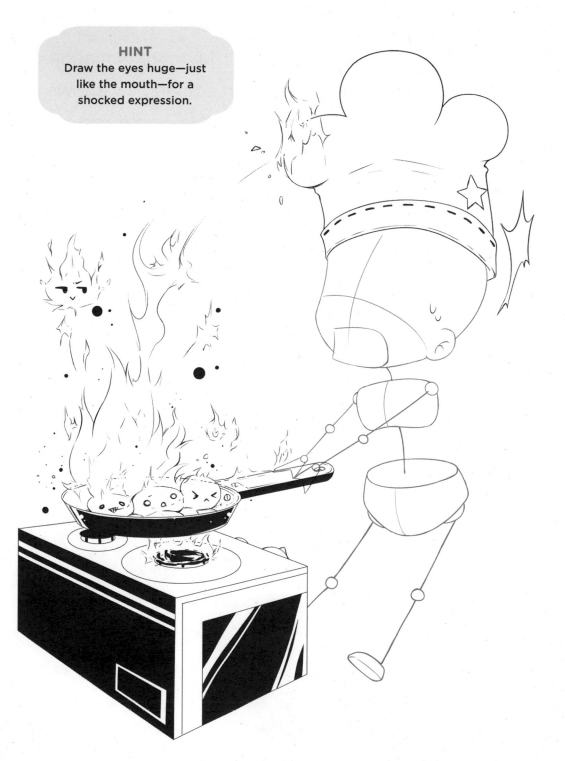

happy food

In manga, particularly in the kawaii style, happy food is an actual character type. Yes, I mean the food has faces with expressions. This includes muffins, scones, pastries, and so on. After you draw the baker, add faces to the floating muffins. Take out your pencils and pile the muffins onto that tray. And yes, muffins with bite marks in them should wince!

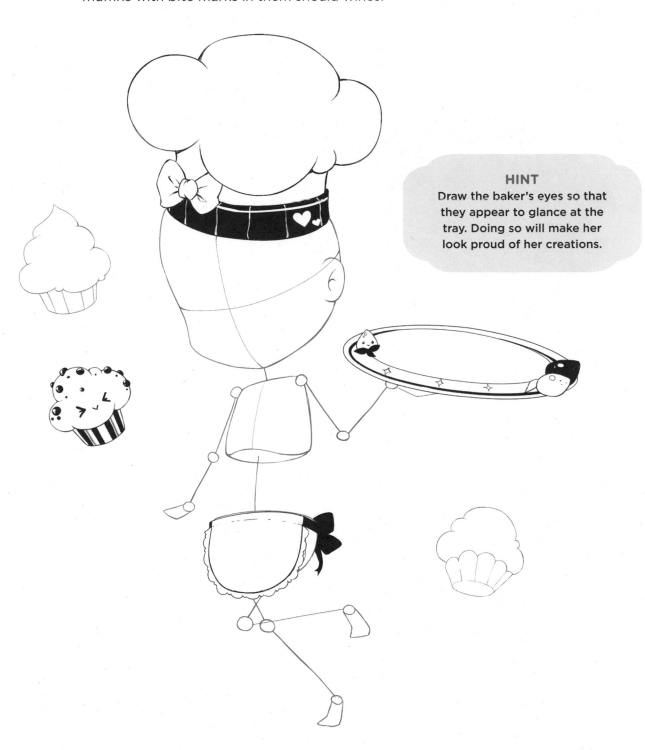

HINT
Draw the baker's eyes so that they appear to glance at the tray. Doing so will make her look proud of her creations.

hibachi chef

If you've ever gone to a hibachi restaurant, you know that not only can the chef cook, but he can also juggle—the food that is. Whether anyone wants to eat juggled food is another topic. However, the diners seem to be entertained. This chef fries up some fish while tossing it around expertly. Draw this star of the kitchen with a confident smile—which you can create by combining a happy mouth and closed eyes.

HINT
Draw his apron so that it flaps, indicating motion.

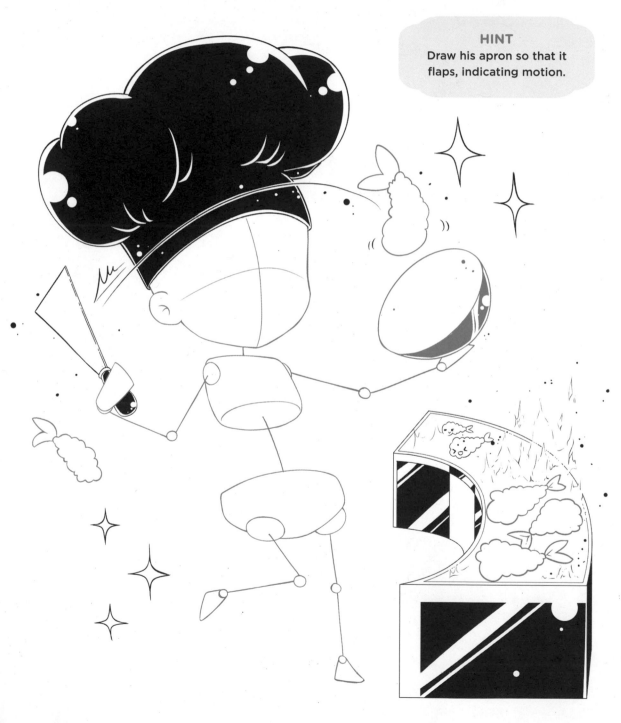

dancing lobster

I don't really understand why the lobster is so happy. I wonder what his expression will be when he gets squirted with lemon. Maybe he's dancing because everyone is so eager to see him . . . especially the diners at table 6! I'll tell you one thing, you won't find me featured on a menu and dancing at the same time.

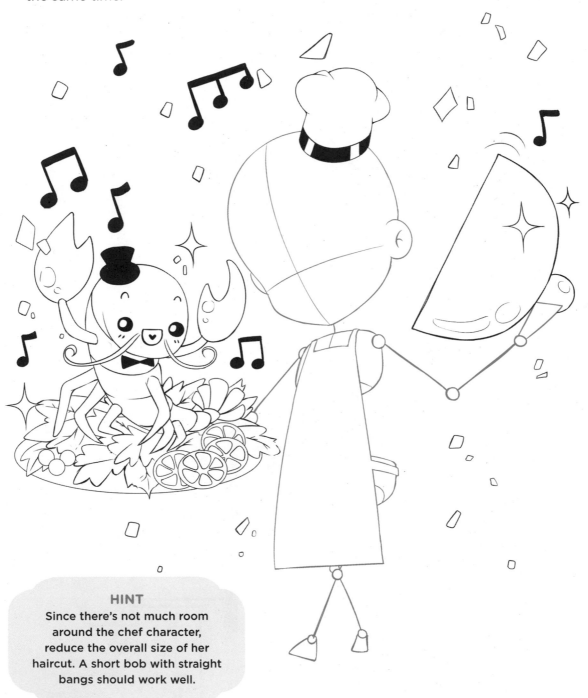

HINT
Since there's not much room around the chef character, reduce the overall size of her haircut. A short bob with straight bangs should work well.

pancakes!
nom, nom, nom!

When you draw the layers of hotcakes, don't make your lines perfectly straight, or it will look like a delicious filing cabinet. Show the syrup dripping all the way down in long streaks with droplets at the ends. Notice the little pat of butter on the top pancake. Why is it laughing? Because the syrup tickles.

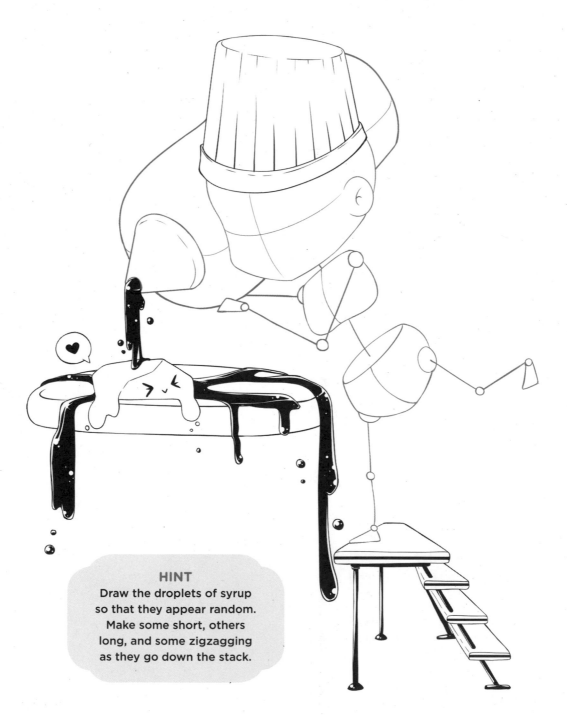

HINT
Draw the droplets of syrup so that they appear random. Make some short, others long, and some zigzagging as they go down the stack.

grilling without spilling

Shish kabobs include many different ingredients, put together carefully. What could possibly go wrong when you're working with sharp metal skewers over hot charcoal bricks? Draw a variety of food chunks for the skewers, including cubes of meat, tomatoes, mushrooms, and sliced onions. You can even throw in something really random like a swordfish—with the sword still attached.

HINT
It might be fun to draw some of the food dropping off the skewers, bouncing on the floor—sort of undercooked.

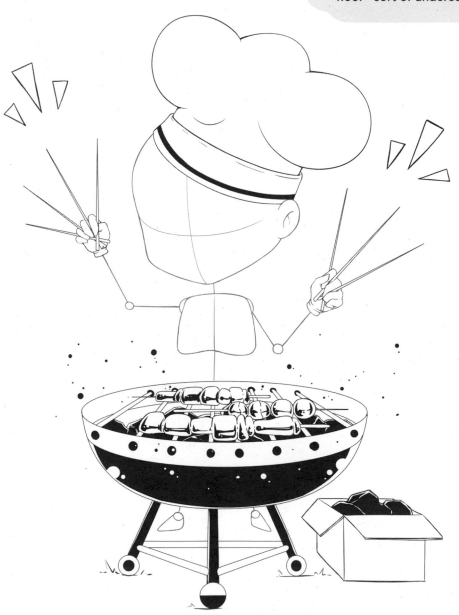

wedding cake craziness

This pastry chef may be about to wreck someone's wedding, but at least she gets an "A" for effort. I wonder if the bride and groom will notice that the chef's turned their cake into a s'more. A sliding cake is always humorous, because once it starts to go, the pastry chef can get as frantic as she likes, but there's no way to stop it.

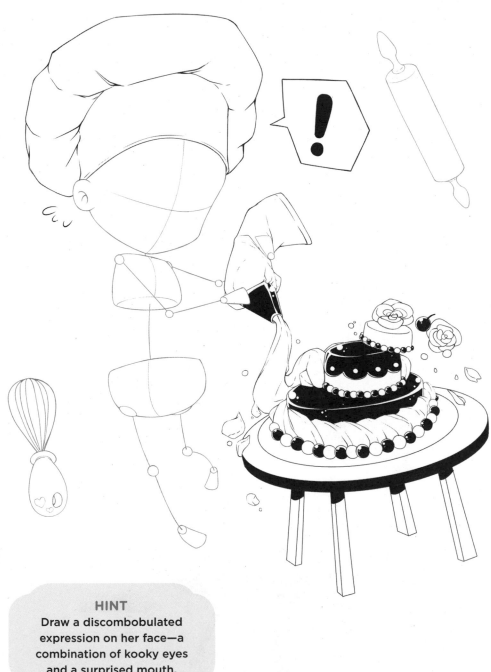

HINT
Draw a discombobulated expression on her face—a combination of kooky eyes and a surprised mouth.

cooking competition

You've seen them all over cable TV—celebrity cook-offs. They are where aspiring chefs are evaluated by judges who are famous chefs with refined taste and nasty dispositions. There's always suspense. If a judge takes a bite and winces, the aspiring chef's career can take a sudden nosedive. Play each character's expression off of the other. Show that one is worried and the other is skeptical.

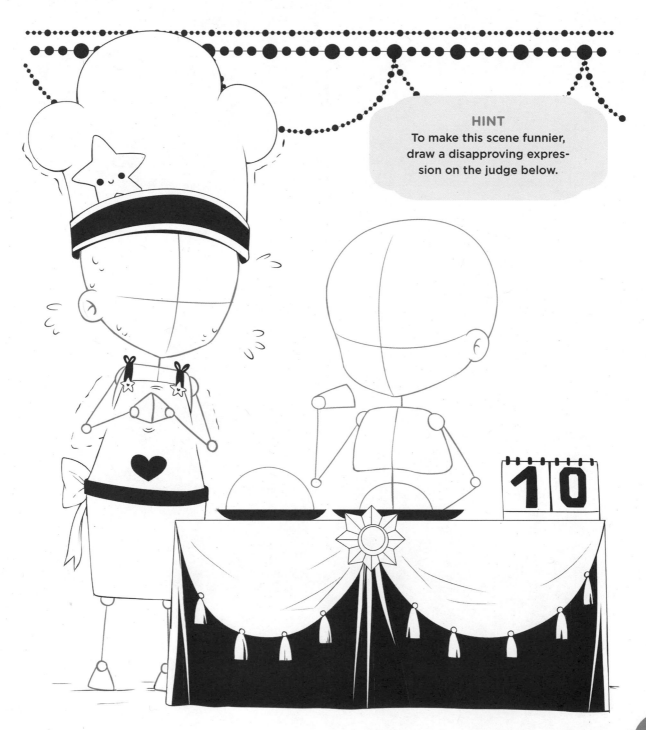

HINT
To make this scene funnier, draw a disapproving expression on the judge below.

11

create manga crafts

In this fun chapter, I'll help you get started creating stationery, bookmarks, and even graphic novel covers. I remember having fun making bookmarks as a kid, which was kind of weird, since I only watched TV. You won't just be drawing. You'll make things you can actually use.

DRAW, CREATE, AND COLOR
YOUR OWN SUPER-CUTE STATIONERY

Receiving a note on hand-drawn stationery makes people happy. So does creating that stationery. In this section, you'll get to create your own, cheerful, manga stationery. There are many themes to choose from—everything from panda bears to little angels. The left-hand pages have the character examples. The right-hand pages feature the stationery. Draw your images around the lined section to complete a page of stationery.

funny bunny

A manga bunny is a chubby ball of fluff with ears. There are virtually no straight lines on these super-cute characters. Everything is round. The arms and legs are tiny. This will enhance this critter's cuteness. Make the tail bumpy—like a little cloud attached to the bunny's rump. Carrots are the natural decoration for the page. But other items work as well, such as lollipops, bows, or flowers.

plump pandas

He's the king of cuteness, the apex of adorable, the pinnacle of precious—
the irresistible panda bear. Pandas are ubiquitous in manga. They have sweet
little smiles, and unique markings. Their heads and bodies are little. Here's
another hint for you: to create an extra-cheerful look, draw the panda as if
it is floating on the page, with no weight placed on its legs or feet.

Hearts provide a pleasing, repeated design throughout the page. Or, if
you prefer, you could draw bamboo sticks and leaves.

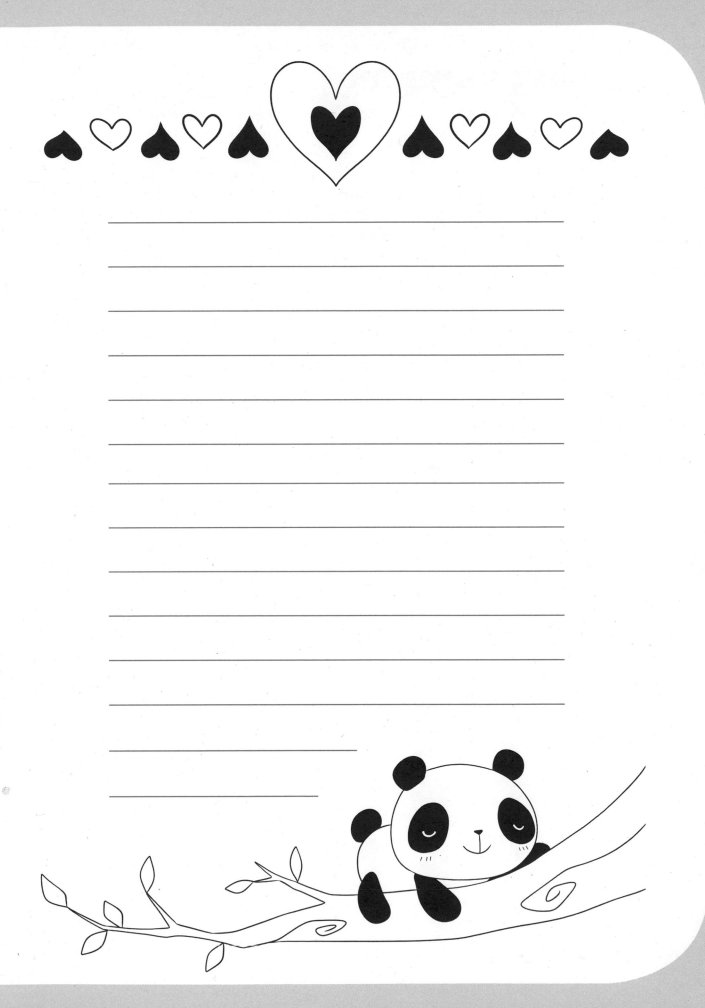

tiny vampire

The tiny vampire is as scary as a gumball with wings. To make an appealing page out of these gothic, undead imps, draw them in a variety of expressive poses. Because their bodies are so small and inflexible, changing their posing looks all the more improbable—and funny. The cape with the batwing-style hem is an iconic piece of clothing. Notice that the hair is drawn with a jagged design. It's all part of the theme—as are the fangs.

Black bats are another good design element. You could also use spiders or skulls.

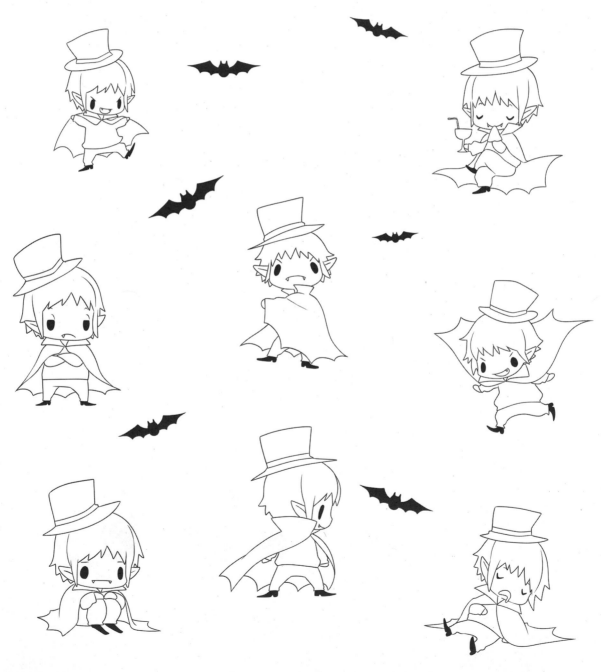

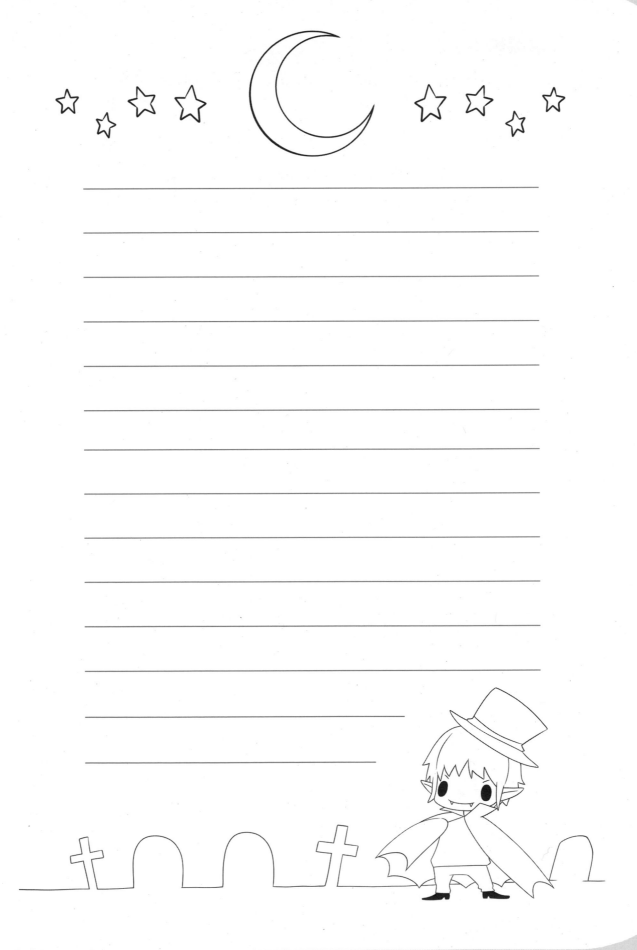

meow!

Kittens are one of the most playful types of manga animals. If not closely supervised, they will get into all sorts of trouble. They have a wide range of expressions—from dewy-eyed innocence to inscrutable malevolence. There are three hallmark items that you need for any cartoon kitten character: a split lip, triangle ears, and whiskers.

Everything else can be simplified, in order to create a classic kawaii-style look. The ball of yarn is a natural prop. It rolls, so the kitten will chase it, resulting in humorous action poses. Other good icons for decorating the page include mice, bowls of milk, and a basket-style pet bed.

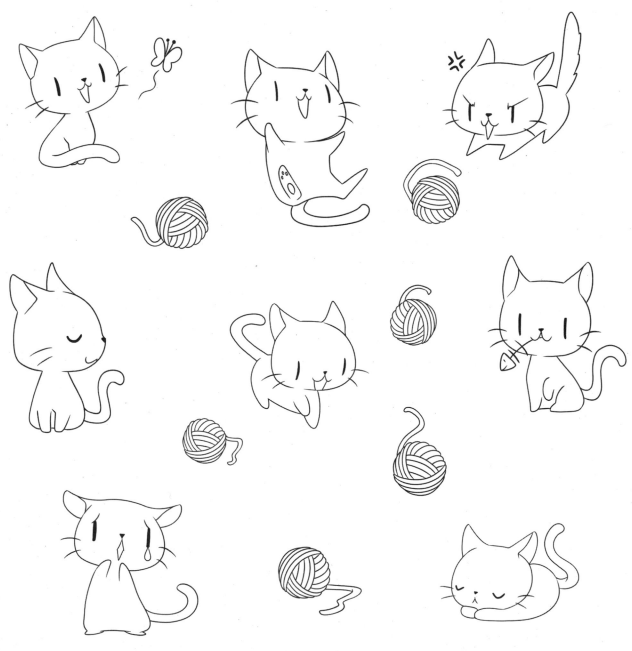

curl girl

This silly and cute chibi has a bubbly disposition. Her hair's the main feature with two huge curls on either side of her head. Draw the head oversized. Draw the eyes super-wide apart and set down low on the face. Omit the nose for a simplified look. Draw delicate arms and narrow shoulders. Finish by drawing a dress that widens at the feet.

Use clouds to represent a joyful, uplifting mood. Other pictorial adornments could include rainbows, ice cream cones, and sparrows.

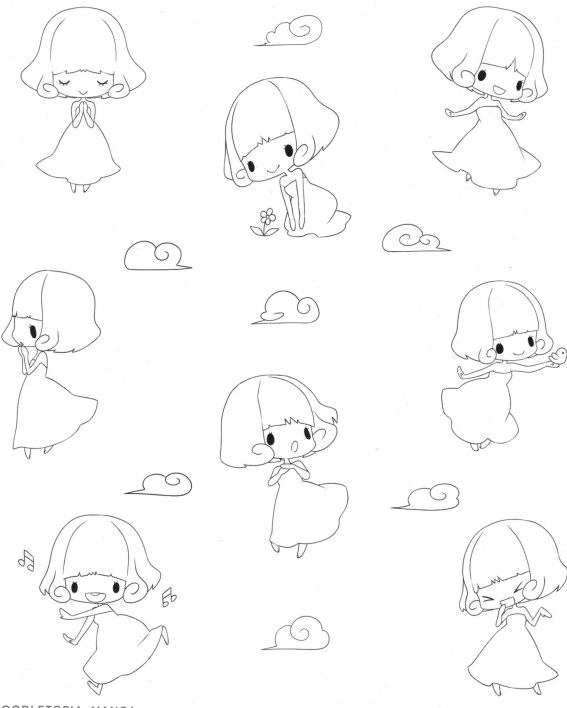

DRAW AND COLOR
YOUR OWN GRAPHIC NOVEL COVERS

Manga fans have stacks of graphic novels cluttering up their rooms. My studio is filled with so many that I have to shovel them out, just to get to my desk.

The most eye-catching aspect of any graphic novel is its cover. They're fun to design because you've got many elements to incorporate: the characters, the setting, and the layout. In this section, I'll show you how to draw the characters that could be used as cover art. I'll show you the steps on one page and on the opposite page you can complete your own cover.

vampire with no friends

Loneliness is a state that everyone can relate to—even vampires. Therefore, it's a popular theme, used to create a sympathetic character.

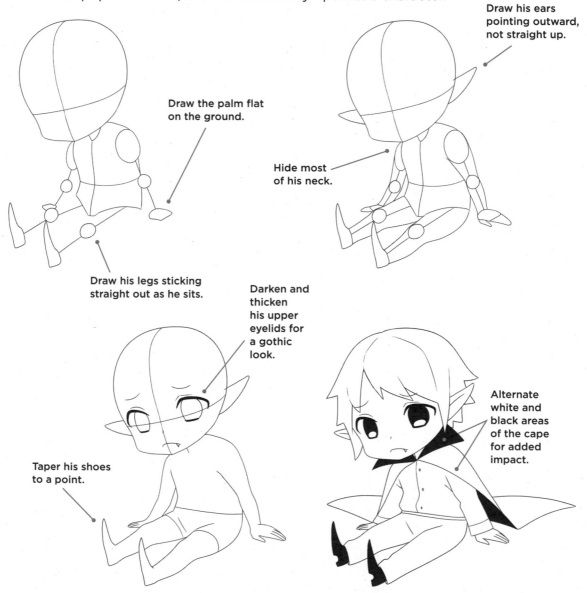

Draw his ears pointing outward, not straight up.

Draw the palm flat on the ground.

Hide most of his neck.

Draw his legs sticking straight out as he sits.

Darken and thicken his upper eyelids for a gothic look.

Taper his shoes to a point.

Alternate white and black areas of the cape for added impact.

Lonely Vampire Boy

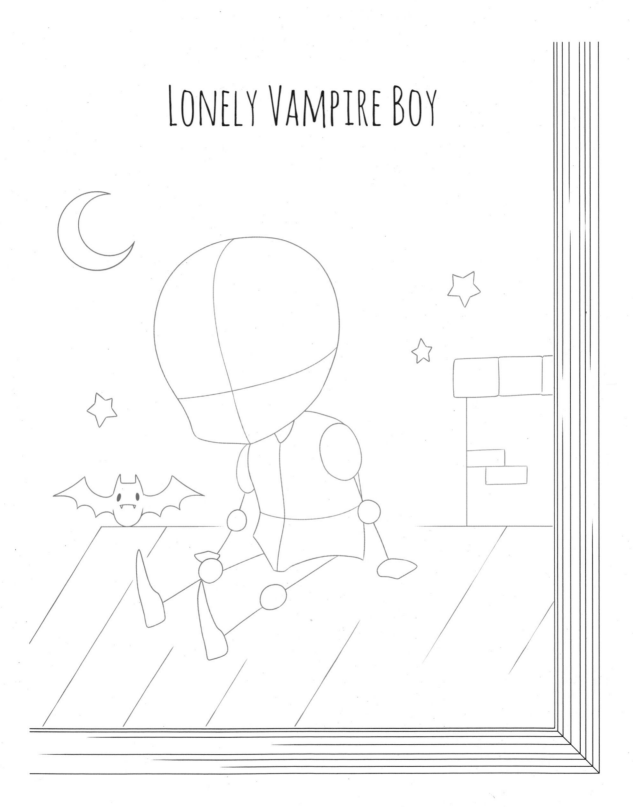

adversaries

The adversarial stepmother and stepchild relationship is another way to evoke sympathy for a character. Of course, not all stepmothers are mean. But this one is a real taskmaster. The better her stepchild behaves, the more she demands of her. The upscale outfit of the stepmom contrasts with the modest clothing worn by the stepchild. (Shades of Cinderella.) Also notice the staging: the mother stands in a dominant position, while the girl sits—in a weaker position.

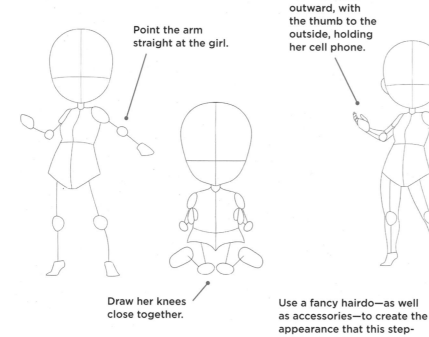

Point the arm straight at the girl.

Turn her hand outward, with the thumb to the outside, holding her cell phone.

Keep her elbows close to the body—a slightly fearful position.

Draw her knees close together.

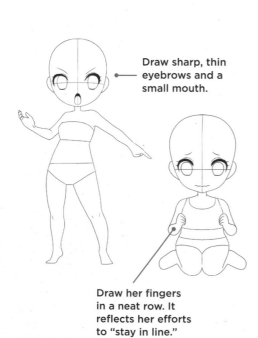

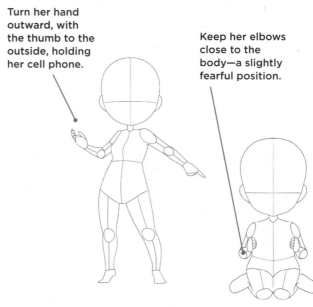

Use a fancy hairdo—as well as accessories—to create the appearance that this step-mother is rich.

Draw sharp, thin eyebrows and a small mouth.

Use a squiggly line for her mouth, representing nervousness.

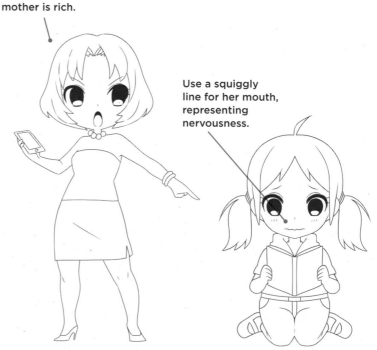

Draw her fingers in a neat row. It reflects her efforts to "stay in line."

MY MEAN STEPMOTHER

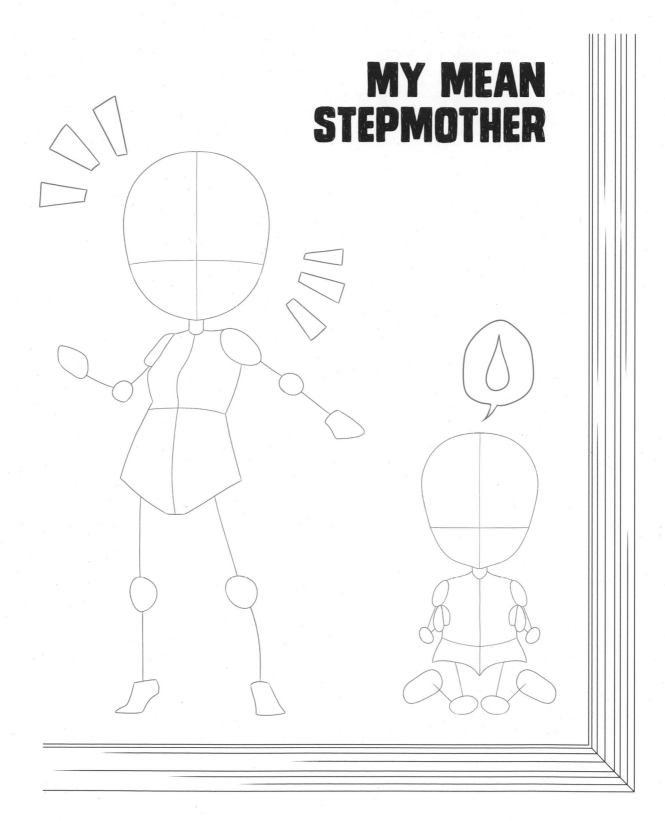

don't leave me!

He said one thing wrong, and now—it's over. Will she reconsider? Sorry, little guy. Better buy a turtle if you want some company. Oh, and by the way, you left your game console at her home. Good luck getting it back.

Funny, tangled relationships are standard fare for manga. Use big emotions for this scene. He is frantic, while she is decisive and composed.

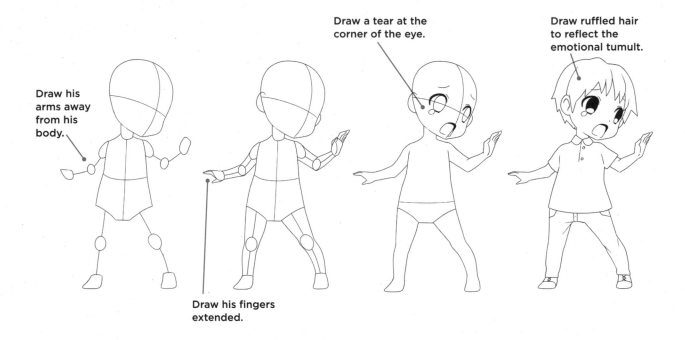

Draw his arms away from his body.

Draw his fingers extended.

Draw a tear at the corner of the eye.

Draw ruffled hair to reflect the emotional tumult.

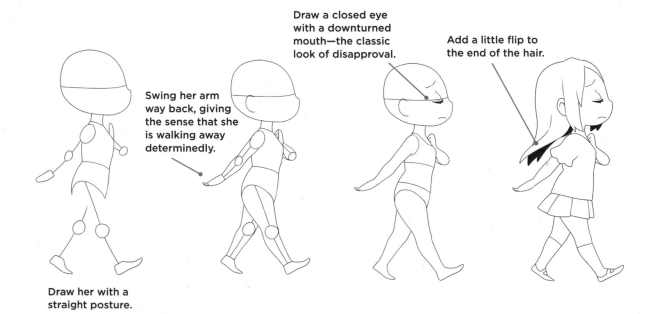

Draw her with a straight posture.

Swing her arm way back, giving the sense that she is walking away determinedly.

Draw a closed eye with a downturned mouth—the classic look of disapproval.

Add a little flip to the end of the hair.

THE BREAKUP

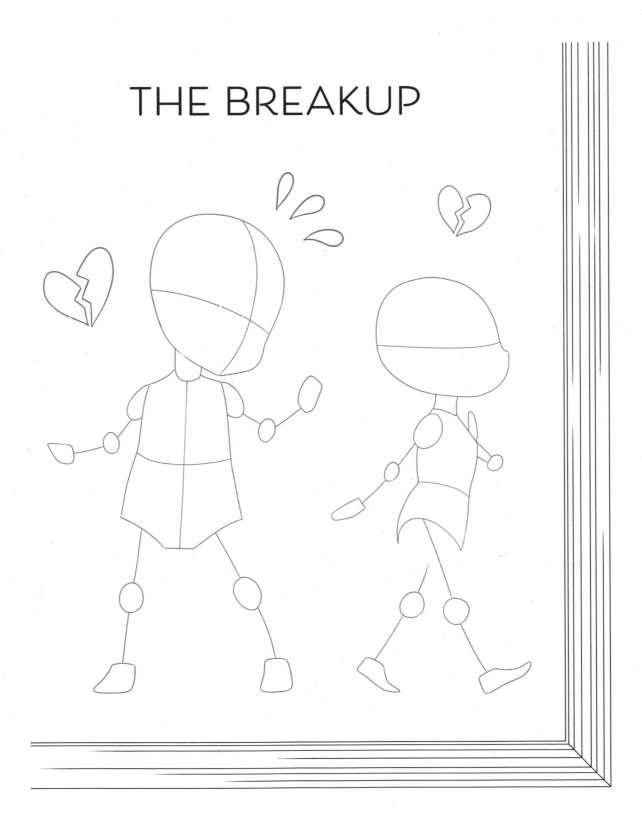

she's number one!

"Reaching for the trophy," and other goal-driven stories have very strong *throughlines* (or story arcs). No story type does this better than one involving a sporting event or a tournament. Everything builds to a climactic scene at the end, where the hero inevitably faces off against her nemesis. But even if she wins, she's unlikely to get a skateboarding scholarship.

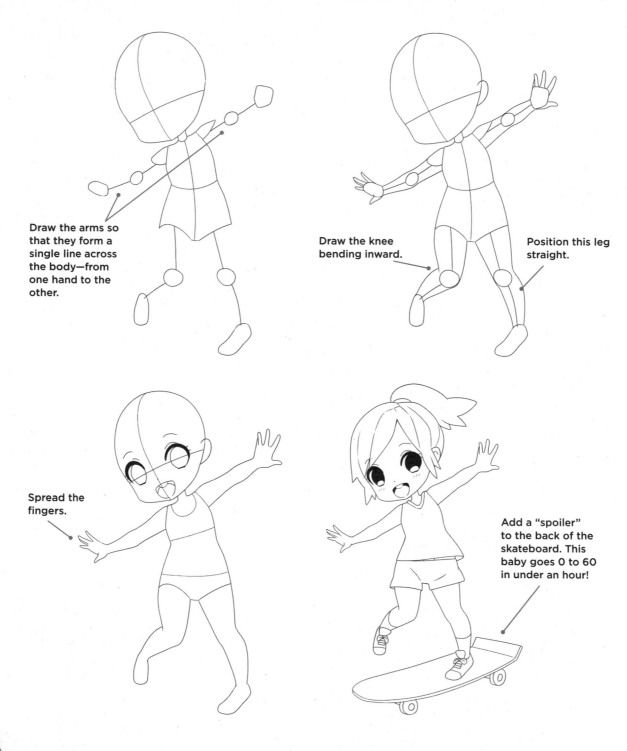

Draw the arms so that they form a single line across the body—from one hand to the other.

Draw the knee bending inward.

Position this leg straight.

Spread the fingers.

Add a "spoiler" to the back of the skateboard. This baby goes 0 to 60 in under an hour!

MAKING MANGA BOOKMARKS

People draw their doodles in the margins of notepads and other books, on scraps of paper, and, when younger, on the walls of their rooms, which results in their computer privileges being revoked. Why not doodle on something that you can actually use when you finish the drawing? Bookmarks are fun to draw and to use. You can copy these examples to make your own bookmarks.

magic moments

How romantic is this? You can create these bookmarks to share with your boyfriend or girlfriend. It's so precious. Look how in love these characters are. I'm going into sugar shock.

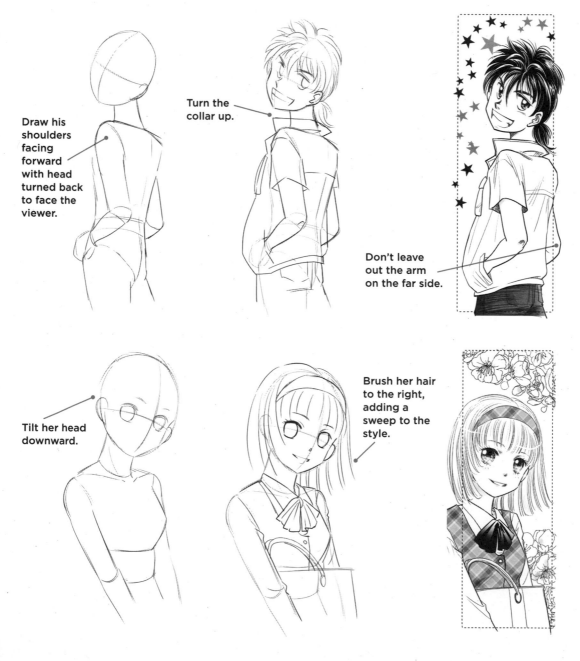

Draw his shoulders facing forward with head turned back to face the viewer.

Turn the collar up.

Don't leave out the arm on the far side.

Tilt her head downward.

Brush her hair to the right, adding a sweep to the style.

fill in your bookmarks!

Draw and color on these two manga bookmarks. Her hair is drawn with delicate streaks, making it look silky. His is casual (i.e., messy).

sports buddies

Tennis and soccer are both popular sports with international followings. Therefore, it's no surprise that they are also popular subjects for manga graphic novels. You can create any type of athlete you like. It's not defined so much by the character's look as it is by the type of uniform he or she wears and the equipment used.

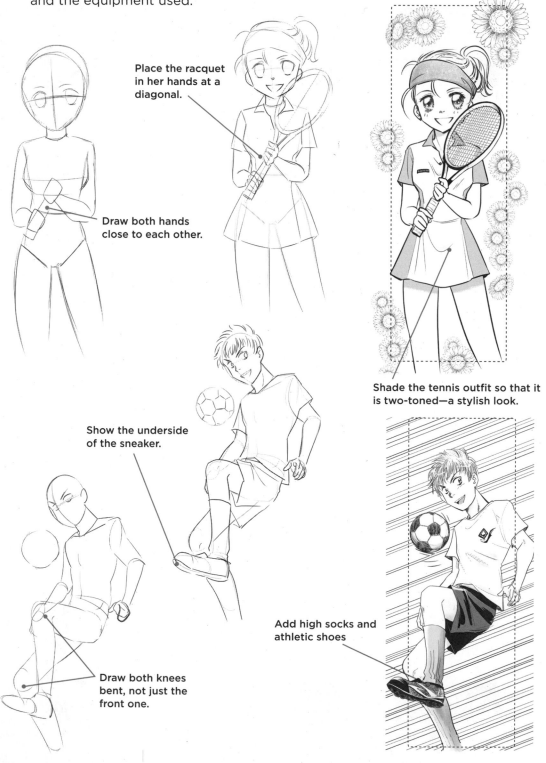

Place the racquet in her hands at a diagonal.

Draw both hands close to each other.

Shade the tennis outfit so that it is two-toned—a stylish look.

Show the underside of the sneaker.

Draw both knees bent, not just the front one.

Add high socks and athletic shoes

fill in your bookmarks!

Draw your own high school sports stars on these bookmarks. Place diagonal streaks behind a character to convey action. You could also draw flowers in the background, as shown on the previous page, or other icons, such as floating tennis balls and racquets.

how do i love thee?
let me text the ways . . .

You no longer need to buy a dozen long-stem roses to show your special someone you're thinking of him or her. Now you simply send a text with a symbol of a flower. It's not that impressive, but at least the symbol won't wilt in three days. I guess it doesn't matter. She looks so in love. And he looks so . . . sort of in love. I can't really tell if he's texting back to her or checking the baseball scores.

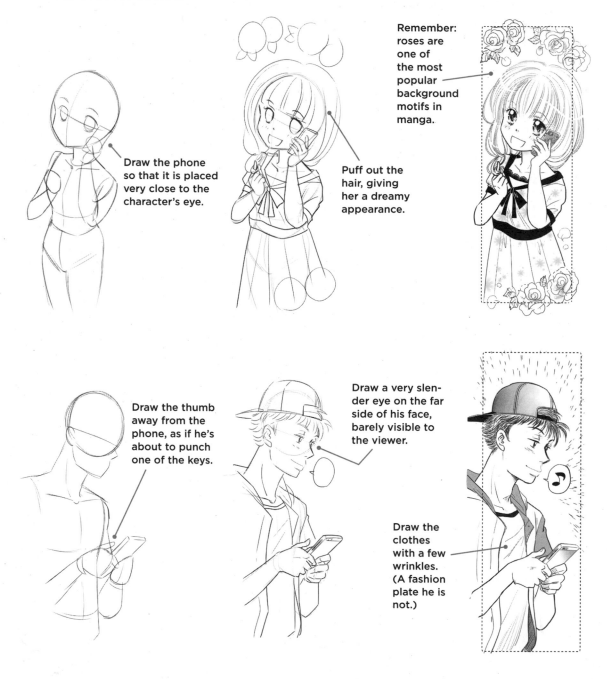

Remember: roses are one of the most popular background motifs in manga.

Draw the phone so that it is placed very close to the character's eye.

Puff out the hair, giving her a dreamy appearance.

Draw the thumb away from the phone, as if he's about to punch one of the keys.

Draw a very slender eye on the far side of his face, barely visible to the viewer.

Draw the clothes with a few wrinkles. (A fashion plate he is not.)

fill in your bookmarks!

If you want to be funny about it, draw both characters frowning, turning romantic bookmarks into "breakup" bookmarks.

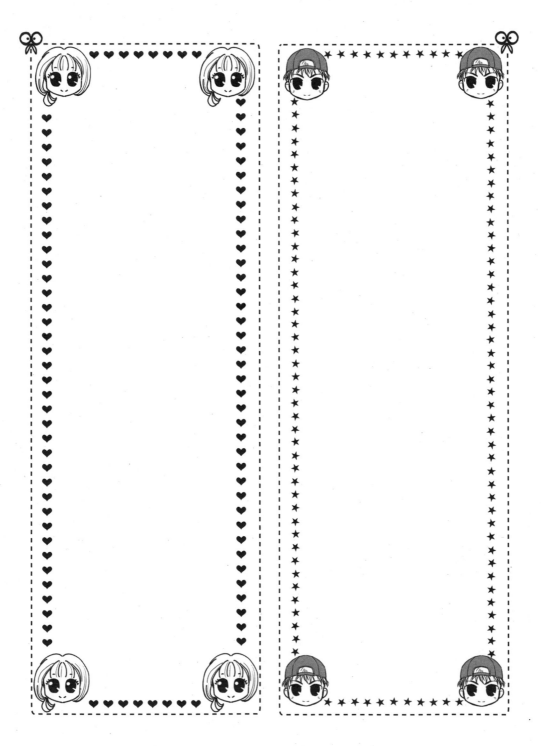

the secret crush

Hmm . . . not exactly sure what she sees in him, but she loves him. And he loves *pizza*. At least they're both in love. These two bookmarks are set against the backdrop of a beach boardwalk. To reflect the beach scene, her skirt blows in the breeze. As for him, he's loaded up with every conceivable fast food from the hot dog stand. This is a good character combo: she's the serious one and he's the funny one. You can play them off each other for laughs.

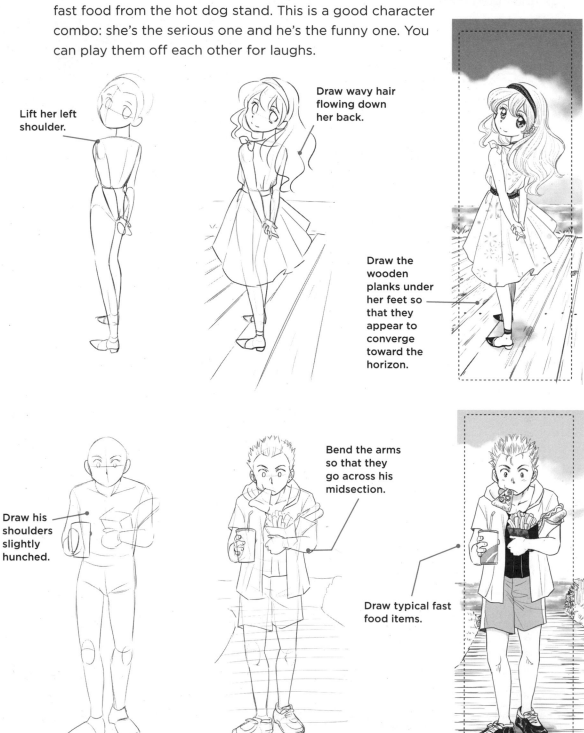

Lift her left shoulder.

Draw wavy hair flowing down her back.

Draw the wooden planks under her feet so that they appear to converge toward the horizon.

Draw his shoulders slightly hunched.

Bend the arms so that they go across his midsection.

Draw typical fast food items.

fill in your bookmarks!

By drawing a background, with a horizon (where the sea meets the sky) in the middle of the picture, you can create the feeling of depth.

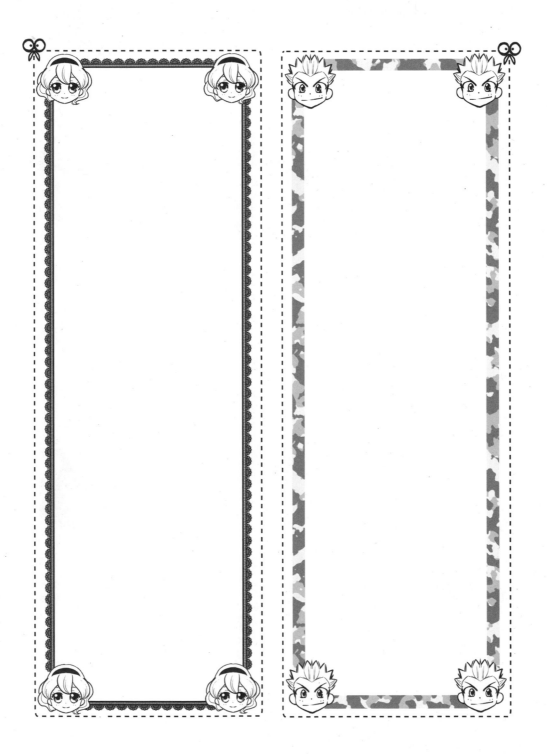

artists at work

With this pair of bookmarks, you will create artists in the process of creating art. Weird. The male character has paint all over him. But the female character is incredibly tidy. How did she make that work? I've never even eaten a bowl of pasta without red sauce leaping up and splattering all over my white shirt. You can draw her as she is shown, or put a smock on her. But if you add a smock, toss in a few splatter marks!

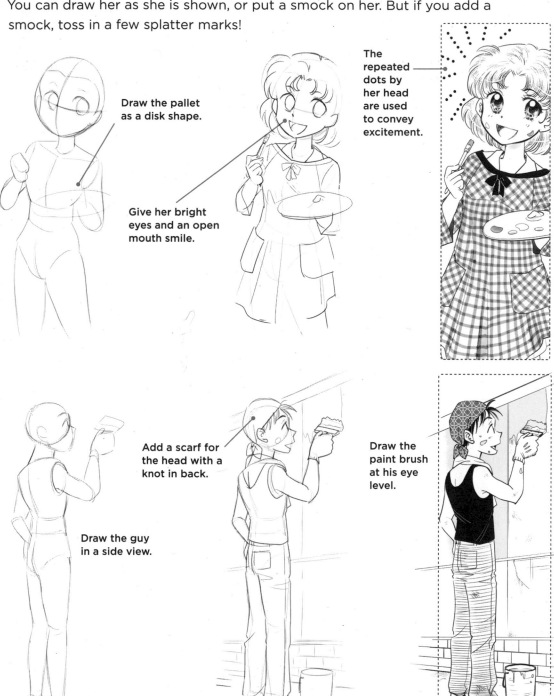

Draw the pallet as a disk shape.

Give her bright eyes and an open mouth smile.

The repeated dots by her head are used to convey excitement.

Add a scarf for the head with a knot in back.

Draw the guy in a side view.

Draw the paint brush at his eye level.

fill in your bookmarks!

The subject matter is painting, so these bookmarks are crying out for color. You can add splotches of color all over their clothes.

doodle free-for-all